MORRIS GRAVES

His Houses ❧ *His Gardens*

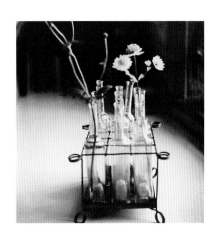

For
loving M

and for
Jan Thompson,
Ward Corely,
and
Richard Gilkey

All rights reserved. 10 9 8 7 6 5 4 3 2 1
Process Media
1240 W. Sims Way, Suite 124
Port Townsend, WA 98368
processmediainc.com

Marrowstone Press
Seattle, Washington

Museum of Northwest Art (MoNA)
La Conner, Washington

ISBN: 978-1-934170-42-7

Book design by Galen Garwood

Edited by
William O'Daly
and
Deborah Mangold

Cover image: Richard Svare Archives,
Morris Graves Foundation Archives,
courtesy Robert Yarber.

MORRIS GRAVES

His Houses *His Gardens*

A definitive look at the houses and gardens
of the reclusive Northwest painter

RICHARD SVARE

Published by Process Media and Marrowstone Press
in association with the Museum of Northwest Art (MoNA), La Conner, Washington

Table of Contents

Foreword

Nine years before Richard Svare passed away, we sat in his small flat in Seattle discussing various writing projects he had finished and those he wished to pursue. As Richard spoke about developing a book on the ancient gardens of Greece, a thought suddenly occurred to me. I suggested he consider writing a memoir, particularly of his time with Morris Graves, his close companion throughout most of the fifties and sixties. He deeply inhaled a squall of air and his jaw clamped down, then set like Norwegian glacial ice. He looked at me with narrowed eyes: "Absolutely not!" The idea of writing anything about Morris, particularly while the legendary painter was still alive, was abhorrent to him. "I'll have nothing to do with what might possibly be perceived as gossip—no retelling of those overhashed, eccentric tales for which Morris was famous; no anecdotes of our times spent together in Careläden and Woodtown Manor; no fodder for the rumormongers."

"You know, Richard, only you can paint the most accurate portrait."

"Precisely!" he said. "And I shall not do it."

Richard had never written about Morris, owing to his deep respect for Morris's privacy, but also, in his modesty, he didn't want to be perceived as amplifying himself through the reputation of such a master as Morris Graves.

Later that autumn, Richard and I drove from Seattle south to The Lake in Northern California to spend one full day with Morris. I had never seen them together. We spent the afternoon in the garden, drinking tea and drifting through a wide range of topics.

At some point in the conversation, Morris turned to the subject of photography and wanted to know my thoughts about its validity as a vehicle for creative expression. I can no longer recall my exact response, but I will never forget his. He didn't trust photography and expressed, curiously enough, a feeling not unlike certain aboriginal tribes who believe some essential reflection or shadow is captured, then lost from the soul. Moreover, he felt within that instantaneous freezing of reality that the essence of the object captured was distorted. It could no longer function within the natural flow of time. I was aware that he seldom allowed himself or his habitat to be photographed.

That lovely day eventually came to an end. Morris and Richard had a terrible time saying goodbye. Both broke into tears. Neither could speak and it was clear that the special bond they had developed over two decades of a shared

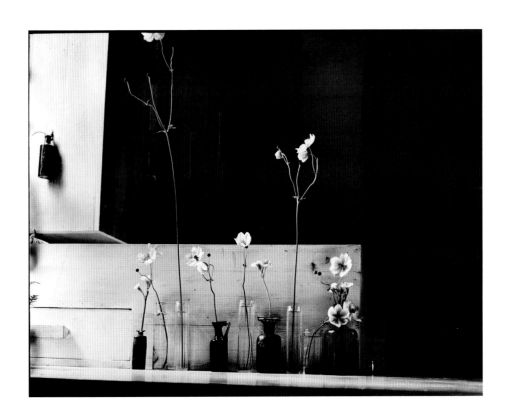

Interior still life, by Morris Graves at Careläden. (Mary Randlett, September 1957)

life remained, its strength evident in their intense respect for each other.

After this last meeting, however, an idea for a book grew. The beautiful simplicity of the idea would reflect upon the notion that Morris, his paintings, his houses, and his gardens were, in his mind, inseparable. They became an exhalation of spirit, fed by the artist's love for what is ineffable in nature—the necessary solitude of a garden, the right tumble of light into a room, the exact placement of objects on a table.

The vibrant interaction of elements and spaces linked the physical to the immutable mystery we find in the paintings of Morris Graves. It was from a place of mutual, absolute trust that Morris encouraged Richard to write this book, which is written as no one else could have.

Richard does not expound on Morris's paintings, choosing to leave such critique to historical scholars. He does not discuss Morris as iconoclast, who allowed his vision to flow toward the East in the counter-currents of 20th-century Abstract Expressionism, his mind's eye sharpened by the philosophies of Taoism, Zen Buddhism, and Tantric Hinduism. This book is not about Morris as prankster or as one of the first "performance" artists, who surely he was; the book is not a comparative analogy of Morris and his contemporaries. While it touches on all of these, this book is about the houses and gardens of Morris Graves, as agreed upon by both men, Morris generously relenting to the use of photographs. Morris died less than five years after Richard's and my visit, and with Richard's passing, both are now gone. We, the caretakers and the publishers of *Morris Graves: His Houses, His Gardens*, are bound by their mutual respect and trust to guard, protect, and keep intact the integrity of this immeasurable gift.

The majority of existing photographs are black and white. Those from The Lake period were taken in color but were converted to black and white for the sake of continuity. The photographs range from simple, anonymous, never-before published snapshots to the more elegant professional compositions by those few friends Morris trusted with a camera. One such friend was Mary Randlett, noted for her photographic documentation of Northwest luminaries as well as her own remarkable photographic art.

The language is distinctly Richard, shaped from his early days of classical voice training and decades of working in the theater, and from his particular view of life, having lived it with a wide variety of influences. Such turns of phrase as "in a trice," "punctiliously thought out," and "promiscuous weather" might sound a bit foreign to the contemporary ear, but they're part and parcel of Richard's "garden" and his irresistible charm.

Richard Svare offers the reader insight into the four self-made habitats of Morris Graves, and he meticulously reduces any personal relationship with the artist to the essence of necessity. This book offers an opportunity to witness the fertility of a remarkably creative mind that bore fruit for us all.

Galen Garwood

Preface

The vivid journey of Morris Graves began with his birth in 1910, in the appropriately named settlement of Fox Valley, Oregon, and ended almost ninety-one years later with his death in 2001, at his house beside his beloved lake in Northern California.

With a peripatetic sense of purpose, he made pilgrimages to exotic destinations in Japan, China, India, and Africa, as well as migratory pauses in New Orleans, Haiti, and France. He painted in the shadow of the Chartres Cathedral, drove leisurely along the Loire River, and made a wintry sojourn in Norway, each adventure offering him stimuli to which he was predisposed.

True to his complex character, he garnered a gamut of impressions that would serve him well: from his stay with Father Divine in New York City, to the extraordinary discussion of metaphysics with Werner von Braun, the analysis of heroics with John Huston, his marveling at the essence of the Irish with Orson Welles, his chatting about plants with a weary gardener, and his heated debates with architects. He was acquainted with many but shared with only a handful of close friends his innermost feelings and thoughts.

The gardens envisaged and created by Morris Graves are described as he originally intended them, with the hope that through the years they would achieve the patina of time that he held in his mind's eye. Some gardens, such as at Woodtown Manor, have vanished almost beyond recognition; yet, in spite of neglect and the encroachment of Dublin suburbia, even the Woodtown gardens tenaciously hold a whisper of their former beauty.

In parallel is the distinct character of the houses he designed (all but 18th-century Woodtown Manor). They progress from the simplicity of The Rock to the grandeur of Careläden, and culminate with the understated elegance of The Lake. These buildings, in their use of indoor and outdoor living space, reflect Graves's passion for both a neoclassical sense of order and his ultimate acceptance of nature's irrevocable course.

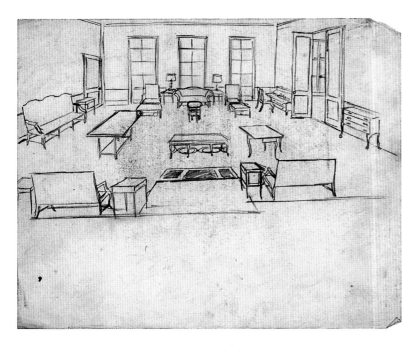

Drawing by Morris Graves, ca.1950, view of living room from fireplace wall at Careläden, pencil on paper, 8.3 x 10.5".

His long and singular journey has left us with the rich vocabulary of a visionary, to which his houses and gardens and, above all, his paintings attest. They all are of a piece—the houses, the gardens, the paintings—joined to one another by the rare aesthetic with which he was so abundantly blessed.

One could walk in and instantly identify a room as one that Graves inhabited. His style of placing objects, paintings, and furniture was unique. An appealing out-of-kilter mood pervaded his rooms, and the ambience would often surprise visitors by effecting a soothing calm.

This combination of mood and effect flowed through his house and garden designs, with the exception of Woodtown Manor, and yet even its

well-mannered façade could not belie Graves's hand in its revival. A Zen master or a Lao Tzu would not have been startled by Graves's inclination toward opposites; after all, it was a characteristic of his paintings. The Yin/Yang principle was evident in his art and his life, and he stood, as E.M. Forster depicted of the Greek poet, Cavafy, "...at a slight angle to the Universe."

With rare photographs from my own collection, from the archives preserved at The Lake (Graves's last home in Northern California), and from other sources—most of which have never before been published—this book pictorially follows the artist's progress in building his houses and the gardens surrounding them. It provides details of Graves's architectural beliefs, his taste and style as reflected in the interiors of the houses, and his theories on gardening and garden design. Drawings of garden plans and the houses he would and did build are also included.

The Houses

Scattered among papers in the various studios of Morris Graves were preliminary drawings, pencil studies, and quick sketches of houses, giving a clear indication of his passion for design and specifically, for designing the house of his dreams. They are consistent in their floor plans, and in three-dimensional renderings their exteriors are similar: severe, utterly proportioned façades of tall exterior double doors and a flat roof.

Architecturally, from the mountain retreat, The Rock, in the Deception Pass area of Western Washington, to Careläden near the town of Edmonds, there were no radical steps in design or appearance. The Rock gives a strong hint of what was to follow at Careläden, albeit on a much smaller scale. The 18th-century Woodtown Manor in Ireland satisfied Graves's admiration with neoclassic proportions. Its plain façade could have been The Rock or Careläden, but with a second story and a pitched roof.

It was at The Lake that a subtle shift appeared in his sense of house design, motivated by the physical situation and a lake lapping at the foundation of the house. However, in all four houses, including the ready-made Woodtown Manor, there is an unmistakable resemblance to those very early drawings (some from the 1930s) when he dreamt of the perfect house and his determination to realize that dream.

The Gardens

Like Claude Monet, Morris Graves drew intense pleasure and inspiration from the garden, which offered an anticipated intermission from the world of fine art. Such a break allowed him to reap the energized solace engendered by that other creative act, the act of cultivating a garden.

Morris Graves developed four highly personal gardens, all in benign climates: two in the farthest reach of the Pacific Northwest, a third in Ireland with his restoration of a neglected 18th-century garden, and the fourth deep among the redwoods of Northern California, beside a black lake.

His tall and agile frame was suited to the often backbreaking labor of creating these gardens, a joy that for many a devoted gardener eventually becomes a liability and for which, in his elder years, he paid dearly. Akin to the especial vision that infuses his painting, his gardens reflect his innate and committed sensibility of nature. The gardens speak for themselves, and however time might dilute or erase their unique character, as is the case with all great gardens, their elegant bones will remain and perhaps even be haunted by his restless spirit.

Repose and meditation with Randlett's nature portfolio prior to photo shoot.
(Mary Randlett, September 1957, at Careläden)

Still life arrangement with Michaelmas daisies in portico at
Careläden. (Mary Randlett, September 1957)

Introduction

The American painter and Pacific Northwest native,
Morris Graves, elicited throughout his profes-
sional career an endless curiosity on the part of art
communities in the United States and abroad. The rea-
son for this can be laid to his original and exceptional
eye relative to the world of painting. No one before
had seen nature and its philosophical impact on our lives
in quite the same way. The influences of Zen Buddhism
and Taoism were a compelling force that permeated his
thought and actions.

The juxtaposed vagaries of his character were often
misunderstood by critics and devotees alike as being
preplanned and self-conscious. This undeniably
contributed to the imaginative lore that surrounded
his life. Fanciful, high-flown, and unsubstantiated
anecdotes about Graves abound, most of them hear-
say and endlessly retold by eager sycophants. It was
always a source of irritation to Graves, and the conse-
quence was his need to vigorously guard and defend
his privacy.

In that most private of lives, the passion for mak-
ing a garden and building a house often overtook the
need to paint. The digging, the transplanting, the shift-
ing of oversized stones, the building of ponds were
normal gardening chores. The results of this labor were
inimitable gardens surrounding the plain but formal
façades of his houses, which reflected his desire for a
Shaker-like simplicity on the one hand and downright
comfort on the other.

To combine the making of art with house building
and gardening is not an uncommon practice among
creative people. One can actively lead to the other and
in the life of Morris Graves, this was inevitable. His
houses and gardens became intaglios of his painting,
and his penetrating glance mirrored each endeavor.

His irrepressible love of plants and of drawing

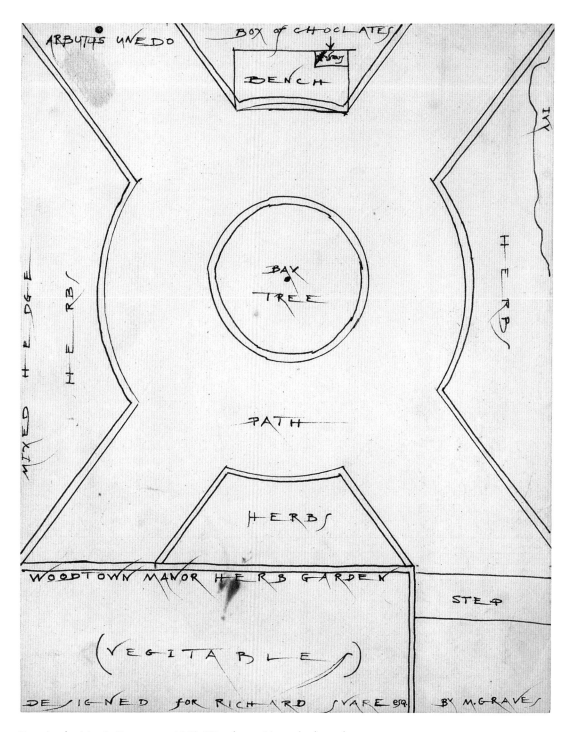

Drawing by Morris Graves, ca. 1958, Woodtown Manor herb garden,
designed for Richard Svare, ink on paper, 10 x 7. 875".

houses manifested at an early age. As a small boy, riding on the Interurban to and from the city of Seattle and sitting on slippery caned seats, he would correctly identify the wildflowers that grew along the tracks as the train whistled through the copses of evergreen trees.

As he grew into a young adult, his inherent love of nature composed itself into a zeal for gardening. In his parents' garden, he poured over sepia photographs of the legendary gardens of the British Isles, France, and Japan, which would later help guide the creation of his own living spaces and gardens.

It is remarkable that in his lifetime he had the force of will, ambition, and steely determination to create the total of four houses and gardens. For most of us, developing a single house and garden is an accomplishment. Graves had the emotional and physical wherewithal to sustain and channel that daunting and often intimidating energy into four memorable retreats.

Significantly, Graves also had the capacity to bid adieu to his projects and begin anew, an act that most gardeners, in particular, would experience as a source of pain and grief. Yet, he yearned to see how certain aspects of his gardens had matured, even as nostalgia kept him from revisiting sites of an earlier contentment. Only once, later in life, did Graves

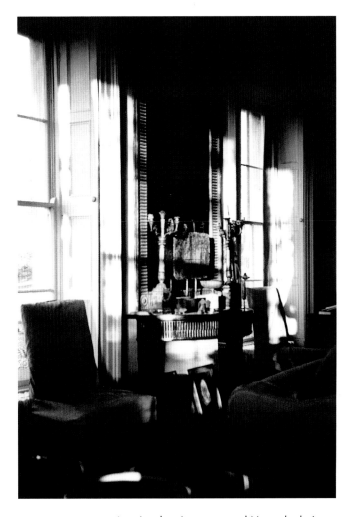

Interior drawing room and Hogarth chairs at Woodtown Manor. (Morris Graves, 1963)

make such a return. That visitation, to the grounds of The Rock, was far from successful. Regarding the untidiness of the paths, the general disrepair of the house exterior, and the increasingly forlorn aspect were enough to dissuade him from paying further visits to earlier dreams.

When most men and women reach their mid-sixties, they retire and look back. For Graves, it was time to begin his final enduring endeavor—The Lake. It was here that he realized his greatest wish; even in gradual decline, he experienced personal transformation. In his closing moments, he well may have cast a fading glance contentedly over the quiet and serene surface of his forest lake.

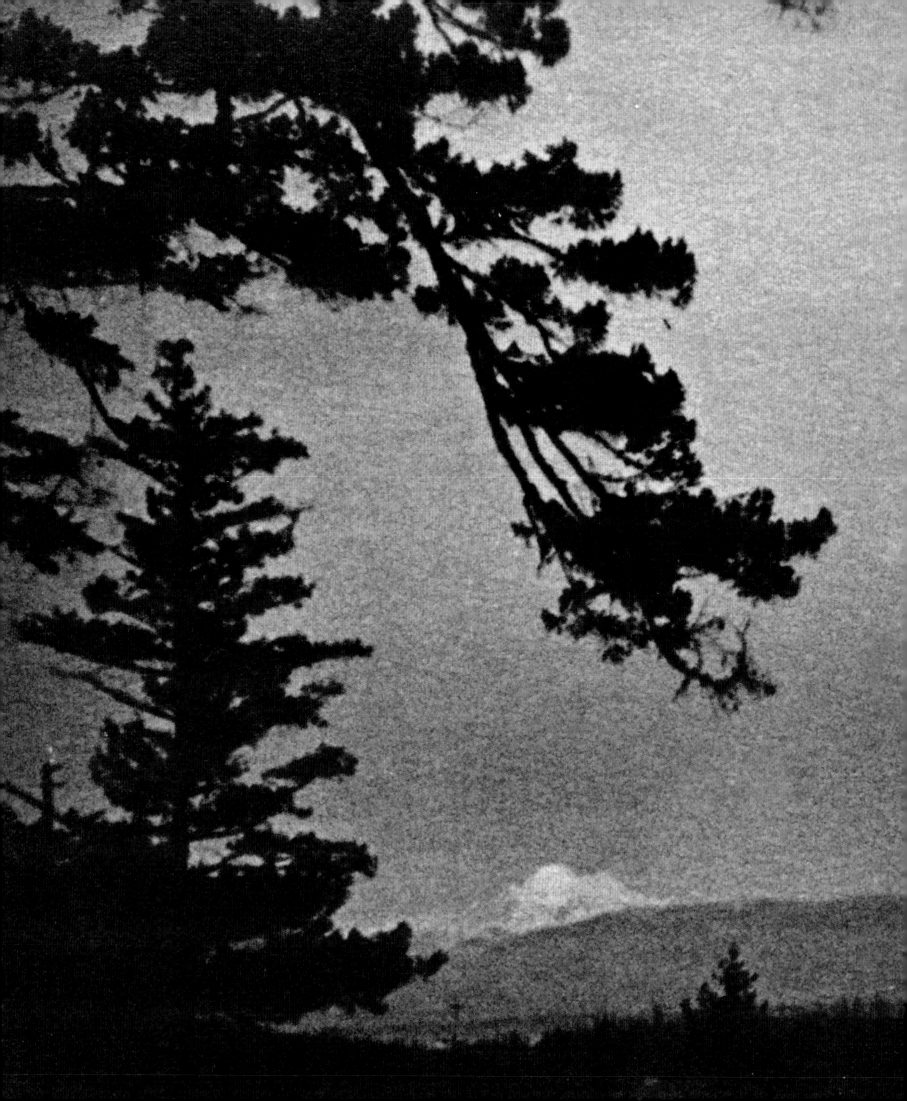

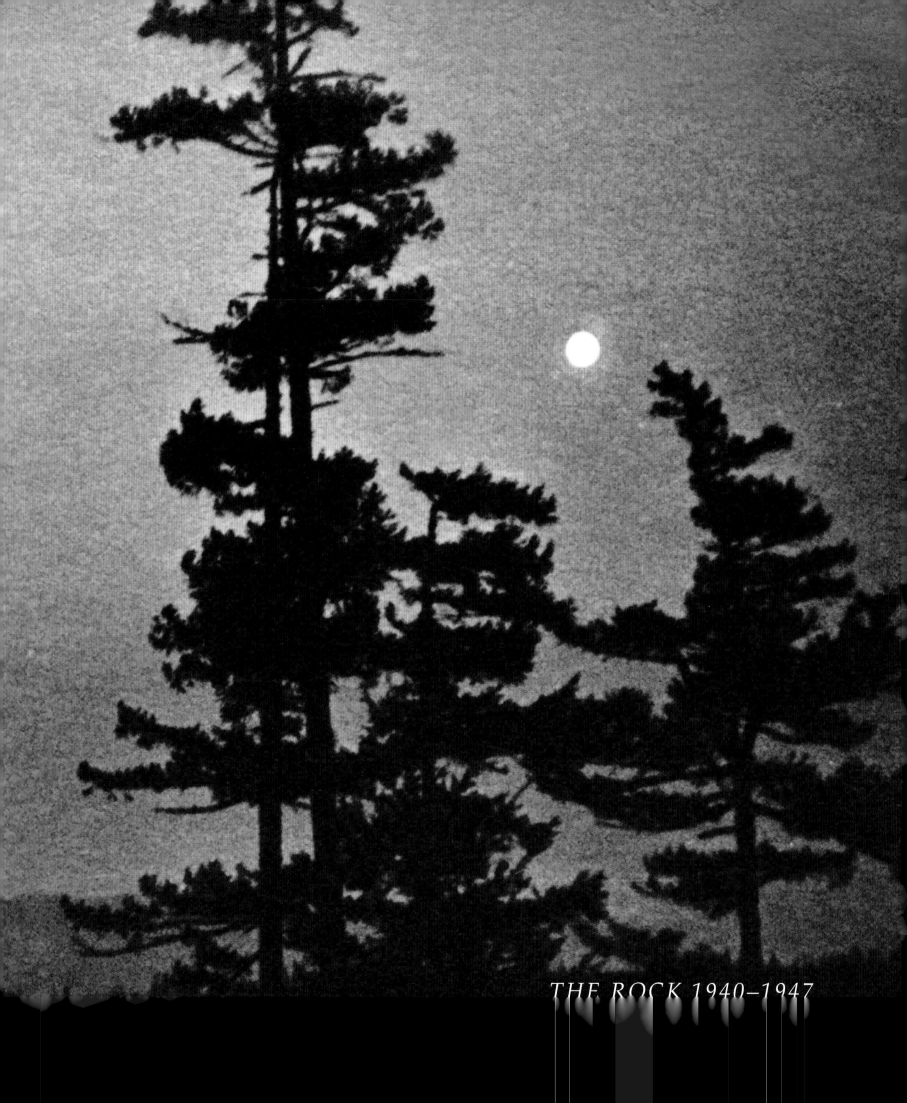

THE ROCK 1940–1947

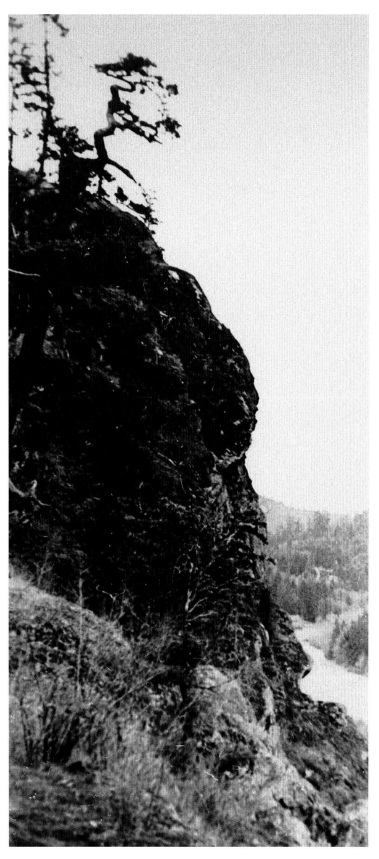

'*Sung Tree*' as inscribed on the back by Morris Graves.
(Frank Murphy, ca. 1940)

previous spread: Moon over Mt. Baker.
(Frank Murphy, ca. 1940)

On the easterly edge of Washington State's treasured Olympic Peninsula, bordered by Whidbey Island and perched on a dizzying precipitous slope high above a lake on one side and stupendous views on the other, was The Rock, the first house and garden Morris Graves developed.

A garden of herbaceous borders with sweetness and light it was not. Rather, it was astringently formal, with stones arranged eons ago when the earth convulsed in the Ice Age, and was enhanced by Graves's superhuman efforts to move, add, and arrange huge boulders. It was a Zen garden, with its patina of moss that Graves assiduously nurtured some sixty years ago. The garden sat in the midst of old-growth forest of Douglas fir and wind-twisted pine.

The sky above would appear within tantalizing reach and ever-present cloud formations still hover over this secluded aerie where eagles, caught in an updraft, soar at eye level, so close as to glimpse their piercing glance in one's direction.

It was a place to listen—the restless wind soughing through the fir and pine, the bird song, and the swirling water far below the cliffs. It was a place to look and be entirely alone at sunrise and sunset, and in darkest night to observe the planets and the stars, unhindered by urban lights.

Perfidious winter weather could play havoc here, with western winds slamming against lofty trees and stinging rain beating against windowpanes. When dense clouds enshrouded the peak, the world below would disappear. The antitheses were the sublime Indian summer days of which the Pacific Northwest is blessed, no more than at The Rock. The delineations of the grand vistas of Puget Sound were sharp and at sundown, the lowering of the western sun silhouetted the majestic crests of the nearby Olympic mountain range.

Only a modicum of imagination is required for those who knew Graves to picture him in the early

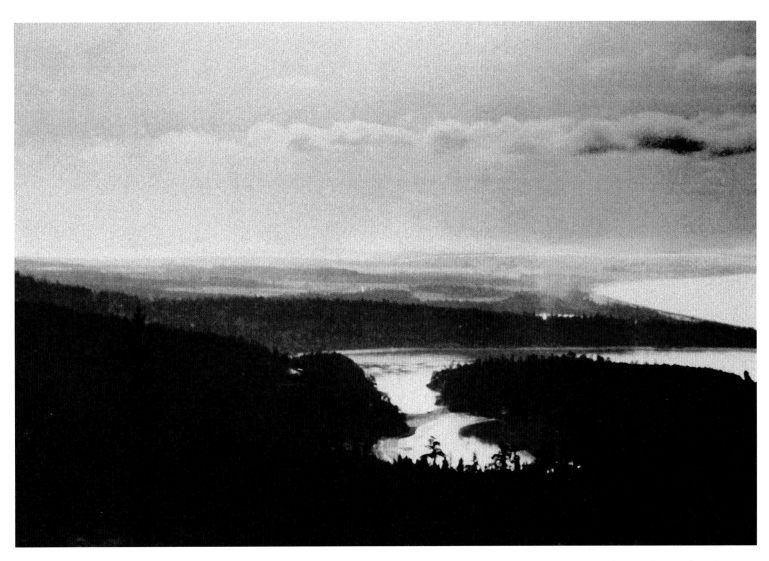

Looking south from The Rock. (Frank Murphy, ca. 1940)

stages of building his house at The Rock. The excitement engendered, with the breaking of ground and the laying of the foundation, was at its zenith. On this forested crest, the impassable haven for which he had yearned was taking the shape he had drawn so many times on scraps of butcher paper. His was a slow process, and that slowness would plague him whenever he embarked on more ambitious projects, such as Careläden and The Lake.

At that moment, however, Graves was completely engrossed, nigh obsessive, in making The Rock a reality, come what may. The disadvantages and difficulties of The Rock's physical situation would have dissuaded most anyone from even considering the location a place to call home. Yet, the challenge didn't deter him for one instant; instead, it goaded him to accomplish his dream of creating a habitation of solitude and peace.

It takes a stolid resoluteness, of the kind that drove Graves's forebears westward to the Pacific Northwest, to contemplate living on an isolated and disjunctive mountaintop, let alone to persevere with the élan and the style that became trademarks of his personal life. This trait would also carry over to the interior spaces of his houses and the design of his gardens. The hermitage on The Rock was, despite its formidable aspect, formal and aloof. It was the essential Graves—at times courtly and always removed.

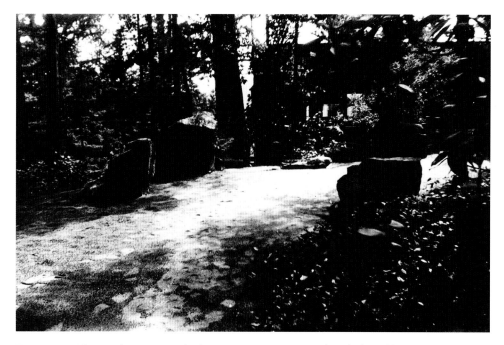

Entrance to The Rock compound where stones were moved and placed by Graves himself. (Photo by Frank Murphy, ca. 1940)

A dirt lane, off a county road, would eventually terminate at The Rock. The road could be easily missed, as there was no indication of a passable way. What did exist was a deeply rutted track that maneuvered through thickets of alder and maple trees and, as the track ascended, agéd evergreens.

In due course, at a clearing, Graves would install a primitive barrier with a handwritten sign nailed to the gate, succinctly declaring: "NO ENTRY, NO VISITORS!" From the very beginning, the possibility of being disturbed was anathema to his working and private lives.

True to his character, Graves knew the moment he first espied the ridge where precisely he would place his simple studio-house: on a small table of land that would accommodate its modest size. The land abruptly falls away from the site on its steep western face and is densely covered in trees, providing a green camouflage, one of many natural features that delighted him.

Graves also knew from the start what kind of house he wanted to build. For the rare visitor, after a jolting ride up the mountain track to the gate and after trudging through underbrush, missing or disregarding the no-trespassing signs, the first glimpse would be of a black-stained board-and-batten façade, anonymous and plainly ominous. The entry door and the large double doors to the studio were made to disappear into the framing of the house, enhancing the sinister effect. Surely, for such a visitor, any closer approach would seem foolhardy.

On the other hand, approaching the house was a quiet exercise. Fallen pine needles strewn along the way muted the sounds of footfall. The majestic stones—those arranged by Graves and those arranged by nature—guided the visitor to the generous double doors of the main entrance. Clues to Graves's deep engagement with Buddhism were everywhere the eye chanced to fall: the beach sand he had laboriously collected was luminous at nightfall; Bonsai trees, garnered on highland treks, were placed in found containers and arranged in groups around the doors; and abundant moss covered the ground.

The formal aspect of the house, some sixty-five feet in length, was a precursor to the future houses Graves would build. This near-ritualistic insistence on formality was a convenient way to hold at bay not only the uninvited, but the curious and the devoted. Even the double-door entrance to the kitchen—the one most used by Graves himself—posed a further dissuasion for those who might presume an intimacy and use the kitchen door rather than be unceremoniously rebuffed at the front door.

This first kitchen was utilitarian, an expression of Graves's early aesthetic and a circumstance of his financial

situation; the lack of running water and electricity preordained the room's sparseness. A wood stove dominated the space with a neat stack of chopped wood nearby. On the windowed wall facing west, the raised counter held a sink, without faucets, composed of two tin basins. Here, Graves washed his few dishes and himself. He was fastidious, not only about cleanliness in his home but of his person, as well. Later, when he decided to absent himself behind a short beard, he was meticulous in its grooming.

A characteristic of The Rock's interior—and of the other houses he would inhabit—was the homely and reassuring aroma of wood smoke from fireplaces and wood stoves. (Much later, in Ireland, the peculiarly heady redolence of peat pervaded the rooms of Woodtown Manor.) The fragrance clung to upholstered furniture, curtains, carpets, and clothes. It was a comfortable aura that followed Graves's person, akin to the long, worn tweed coat in which he wrapped himself.

From the kitchen, a door led into the studio area. A bedroom was next to the largest room of the house, the simply furnished living room with a fireplace restrained by its outline of slate-colored marble (another forerun-

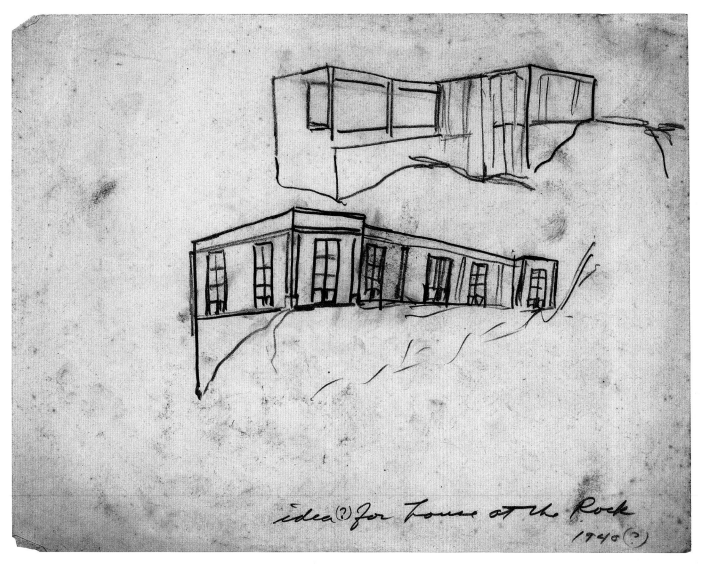

Early idea/sketch of house at The Rock, by Morris Graves, ca. 1940.

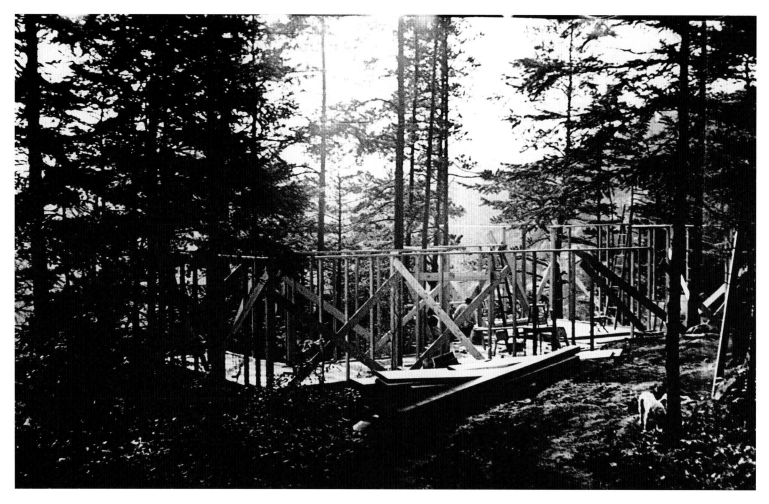

House under construction at The Rock. (Frank Murphy, 1942)

ner of future hearths in the houses he would design). The most prominent feature of the living room was a bay window that terminated a slight extension of the room's western wall. The limitless view from the bay window was framed by thick, twisted branches of a venerable pine and looked down the steep slope to the water below. Opposite the window, the double doors opened onto a small, enclosed garden where Graves had developed a raked sand area in the tradition of the Roan-ji Zen temple garden in Japan.

The other rooms of the house had no interior walls, and the only room that presented itself as a complete entity was the living room. Its walls were paneled in vertical rough-cut cedar with a wainscoting; the fir floor was stained a dramatic black. Together with the room's contents, the space was a precursor of all the rooms Graves would occupy in the eventful years to come.

A Queen Anne-style narrow sofa stood opposite the severely simple hearth, accompanied by a Chinese Chippendale chair. In one corner of the room was a square, mahogany gaming table upon which Graves was wont to place a large, nut-brown Chinese ceramic vase. This same container, with its classical proportions, moved with Graves from house to house and today resides at The Lake. This vase figures prominently in several of his drawings and paintings. Here, at The Rock, the vase held branches of wild roses, whose reddish stems would dry to a silvery sheen. On a corner wall near the square table, Graves pinned a black sheet of Chinese rice paper flecked with gold.

The placement of the table, the objects on it, and the backdrop of the black paper were inherent to Graves's sensibility. With authentic frequency, the studied arrangements of furniture and objects would recur, again and again, at Careläden and Woodtown Manor, and with his increasing prosperity became all the more elaborate, enhanced by a myriad accumulation of treasures at The Lake.

In the Graves tradition, the placement of the house was punctiliously thought out. He had identified the exact setting, and so to inform the final design he first considered the pine forest. Secondly, he surveyed the views to western shorelines. During construction, he remained aware of the various forms of vegetation in relation to the open space and of the environment as a whole. With such awareness and concern for his surroundings, he situated the privy in a small copse of trees nearby.

Aside from occasional visits to Seattle to see his mother and a few friends, and to replenish painting materials, Graves stayed close to The Rock. He chopped the daily stock of wood for the stove and fireplace, manicured the system of paths, and nurtured the moss. Beyond these few tasks, he allowed his peak to succumb to the wiles of nature.

The nights secreted his favorite moments. He would sit

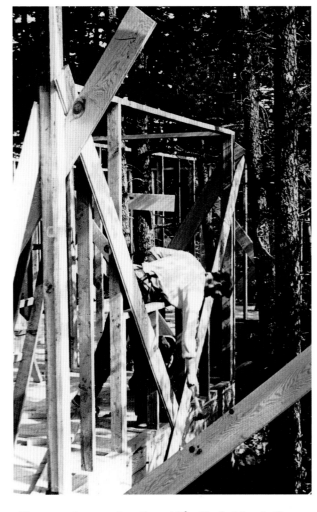

House under construction at The Rock, Morris Graves with hammer. (Frank Murphy, 1942)

on a rough, wooden bench he had devised near the cliff's edge and listen to the waves below. The pervasive nighttime silence of The Rock was broken, ironically, only by Graves himself. One starlit night, on a ramble near the declivitous edge, he was moved by the utter quietude to sing a series of clear notes, which within seconds retorted back in identical tones. To his delight, he realized that the peculiar configuration of his mountaintop—the cliff providing a sounding board and the small valley a base—proffered the ideal conditions for producing echoes. Graves could not resist and so indulged in several consecutive sessions of nocturnal warbling, until a resident of the valley below, having his sleep interrupted once again, shouted up to Graves to "Pipe down and go to bed!"

The quietude that was peculiar to The Rock came to an end under circumstances that, at first, baffled Graves. At nearby Whidbey Island, the naval air station became particularly active during and after World War II. On training exercises, the propeller planes flew over the vicinity of The Rock and on one occasion, a plane flew so precariously close to the peak that the house shook. Graves, alarmed, bolted from the studio. The plane flew at eye level and Graves railed at the pilot with an appropriate gesture. It was a mistake to do so, however, and The Rock and its occupant became an ideal target. The earsplitting, mechanistic buzzing became incessant. It was the turning point and the beginning of the end of Graves's idyll on The Rock.

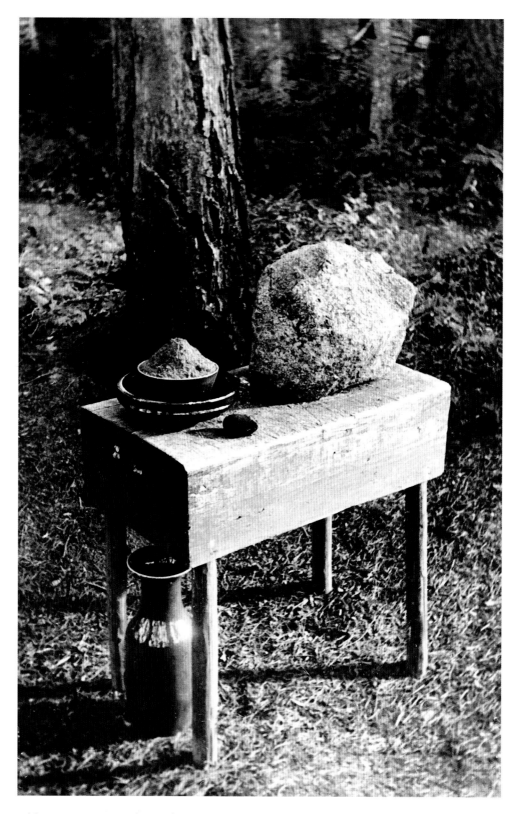

Table arrangement at The Rock. (Frank Murphy, ca. 1943)

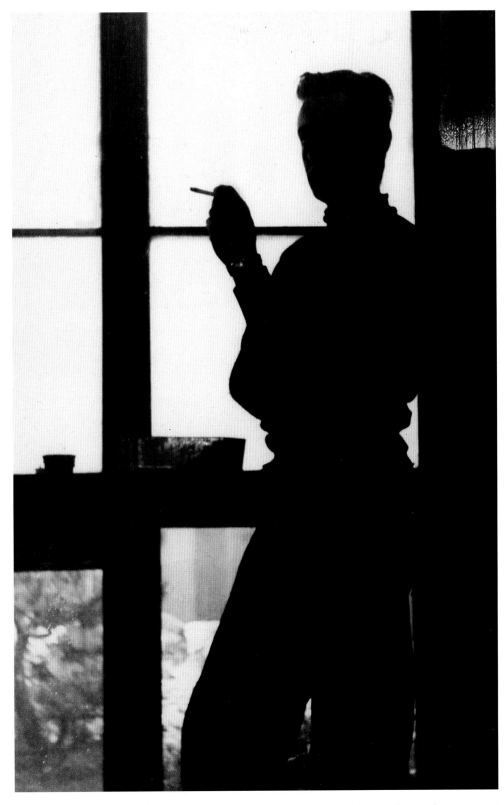

Portrait of Richard Gilkey at The Rock. (Frank Murphy, ca. 1943)

First photograph of Morris Graves with a beard, in bay window at The Rock during construction. (Frank Murphy, ca. 1940)

Acknowledging that his days were numbered there, he began to plan his departure. In addition to the shuddering drone of aircraft engines, the lack of conveniences had begun to take a toll on his patience and time. There were rumors of houses to be built in the valley below, and the aerial harassment soon silenced the bird song of the peak. Graves's leave-taking was a timely decision, as the future would soon reveal.

The Rock ultimately achieved a mythopoeic status in imaginative minds. Certainly, Graves's persona contributed to this phenomenon, as did his place in the history of American painting. The mighty and breath-catching vistas over nearby green hills and far below, the distant horizon, and the waters of the Puget Sound all played a role. Regardless of its source, however, the Rock's emotional pull on its visitors was palpable. The aerie represented one of humanity's lodestars—the hankering for solitude in nature. In this peevish age, The Rock has become, for many, a symbol of one man's effort to distill a miracle.

Postscript

The final chapter in the life of that extraordinary place—a retreat imbued through the years with the intense emotion and creativity of its builder—now lies in a sodden mass of ash and scorched timbers. In a matter of days following the death of Morris Graves at his Northern California home, the sole resident of The Rock accidentally set ablaze the kitchen. The flames leapt with horrific alacrity from one room to the next, until the house and its occupant were no more. The nearby trees were blackened, the copious moss that veiled the great stones was baked away, and the stones themselves, some cracked and splintered by the heat of the fire, remain as ravaged reminders of The Rock's former pristine self. The massive and perhaps cathartic firestorm ended The Rock's enduring serenity and forged another facet of the legend that surrounds Morris Graves.

Morris Graves asleep at The Rock. (Frank Murphy, ca. 1940)

Once More, The Round

What's greater, Pebble or Pond?
What can be known? The Unknown.
My true self runs toward a Hill
More! O More visible.

Now I adore my life
With the Bird, the abiding Leaf,
With the Fish, the questing Snail,
And the Eye altering all;
And I dance with William Blake
For love, for love's sake;

And everything comes to One,
As we dance on, dance on, dance on.

Theodore Roethke

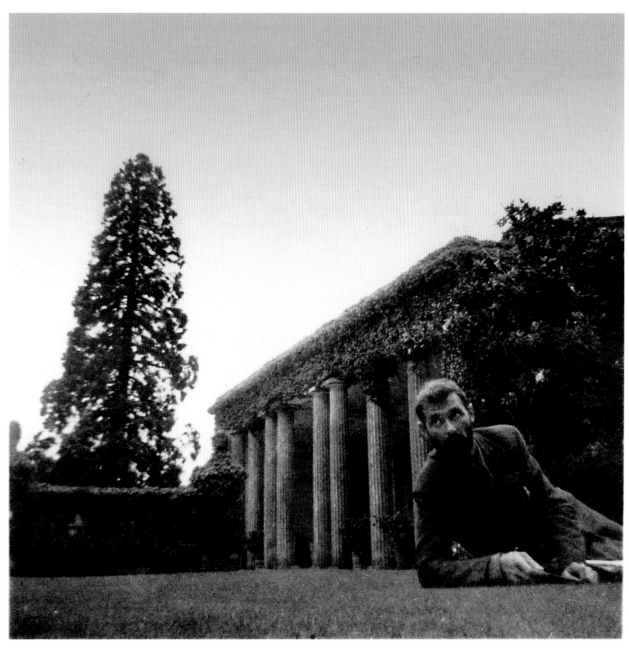

Morris Graves in England, in front of an ancient classical portico that inspired his own design for the portico at Careläden. (Carlyle Brown, 1949)

CARELÄDEN 1947–1957

Careläden under construction: view north
toward studio wing from roof of kitchen wing. (Mary Randlett, April 1950)

previous page: View east from living room out of window to right
of mantled fireplace. (Mary Randlett, September 1957)

As the proverbial crow flies, only about forty miles separate the pinnacled isolation of The Rock and the suburban property where Morris Graves would next settle. In truth, the spacious, elegantly formal, almost palatial setting Graves would develop at Careläden was a world apart from the primitivism he had discovered and cultivated at his island dwelling.

The moment had arrived for which Graves had long dreamt: to build a workable studio in a capacious house and enclose it with an ample garden. He relished the prospect of creating his own private Eden among the tall, graceful native cedar trees that thrived on the acreage.

Just south of the small town of Edmonds in Snohomish County, and a reassuring distance from the city of Seattle, a two-lane tarmac road leads into the heavily wooded enclave of Woodway Park. It was originally developed in the 1920s under the guidance of a New Englander, who envisioned a somewhat mannered and idiosyncratic community of large and sometimes baronial residences of impeccably groomed lawns bordering grand driveways begun at imposing gate piers and wrought-iron gates.

A few august houses were eventually built on the bluff that overlooks Puget Sound, and a railway track below carried frequent freight and passenger trains. Directly east of the main road, less pretentious homes later appeared, on sites of ten or more acres each.

For some residents of this community, it was an unsettling anticipation to have an artist, albeit a well-known one, among them. Visions of bohemian behavior and raucous parties were quickly dispelled, however, and Graves set about clearing the land of brush and unwanted sports of young vine maple.

Graves had scrutinized every inch of the property before he signed the papers of ownership. He was typically thorough in his research, knowing exactly where the house would sit, its approach, and the expanse of future south lawn and herbaceous border. He envisioned two levels of garden and what he would later term as the "lower forty," where he would one day grow vegetables and perhaps raise a few chickens. Indeed, all this and more would come to pass, much of it through Graves's intimidating force of will and his own physical strength when money was

Construction view north through south-wall bay window, opening of dining room to portico, Morris Graves in the distance, standing at studio entrance. (Mary Randlett, April 1950)

17

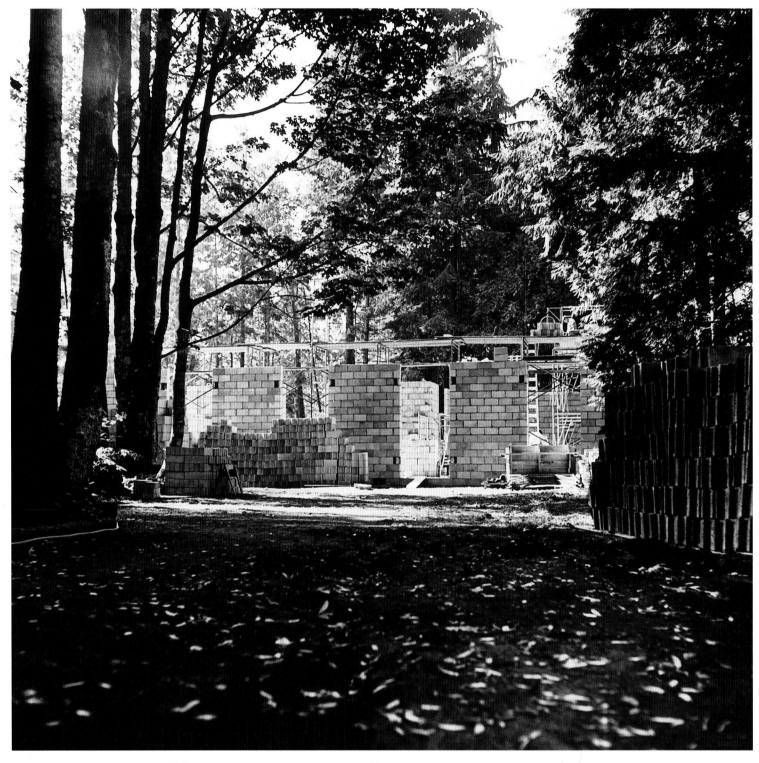

Construction view, west toward front entrance. (Mary Randlett, October 1949)

slow to appear on the horizon.

After living in his relatively primitive but immaculately kept aerie, he foresaw a house of convenience: a kitchen with all the necessary appliances, a roomy bath and uppermost in his plans, a large studio with the essential proper lighting, both natural and electric.

It was at this juncture that Morris Graves and I struck up a friendship that would endure until he died. His prodigious energy was infectious, and together we set about bringing Careläden to a livable state. But the process of building the house and studio would, too frequently, be excruciatingly slow and beset by a plethora of problems, chief among them, rising costs. The temporary solution was to construct the planned gatehouse first: two small buildings with a covered breezeway or drive-through. One would consist of a small kitchen, space for a bed, and a wood-burning stove. A separate bathroom with toilet, washbasin, and shower would complete the interim living space, as he regarded it, until the larger house was finished. He was to live in the gatehouse much longer than he had planned. Opposite the first, the second building would be used for storage during the years he resided on the property.

Gatehouse with covered breezeway and drive-through.
(Mary Randlett, September 1957)

Early on, construction delays were the unpitying stepchildren of regular, monotonous occurrences—anxiety over money, the lack of available materiel, and countless other logistical and physical problems. Graves began to refer to the house by the name of "Careläden," adding, some believed, a too-whimsical umlaut over the second letter "a", by which he pronounced it *carelawden*. From then onward, Graves and his close friends would call the property by that name.

During the interminable hiatuses that were often beyond his control, Graves worked slavishly to clear underbrush from the property. Hour after hour, he removed rocks and stones from the proposed lawn area, and brought in and spread soil to even out the terrain. He endlessly raked the new area and at long last spread grass seed. Along the lawn's western edge, he measured and laid out what was to become a spectacular herbaceous border of annual and perennial plants: the tall, purple-flowered Poor Man's Orchid (*Schizanthus pinnatus*), pale blue Siberian Iris (*I Sanguinea, I. Oreintalis*), various Astilbe (*Saxifragaceae*), Avalanche Feather Reed Grass (*Calamagrostis x acutiflora*), and, as a backdrop, luminous Shasta Daisy (*Chrysanthemum maximum*) and Michaelmas Daisy (*Aster novi-belgii*). Eventually, the border would reach an impressive one hundred feet in length.

The next project was to enclose the property as efficiently as possible. An epically proportioned cement block

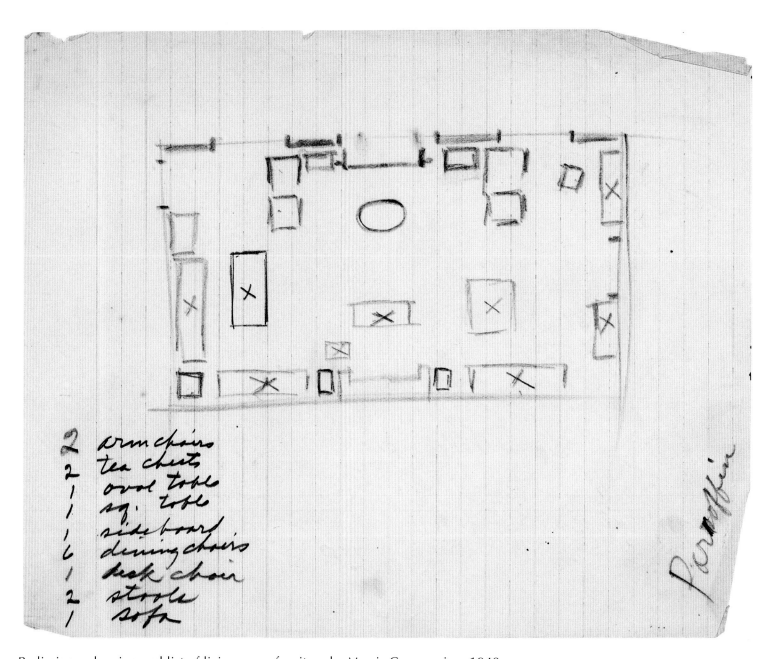

Preliminary drawing and list of living-room furniture by Morris Graves, circa 1940s.

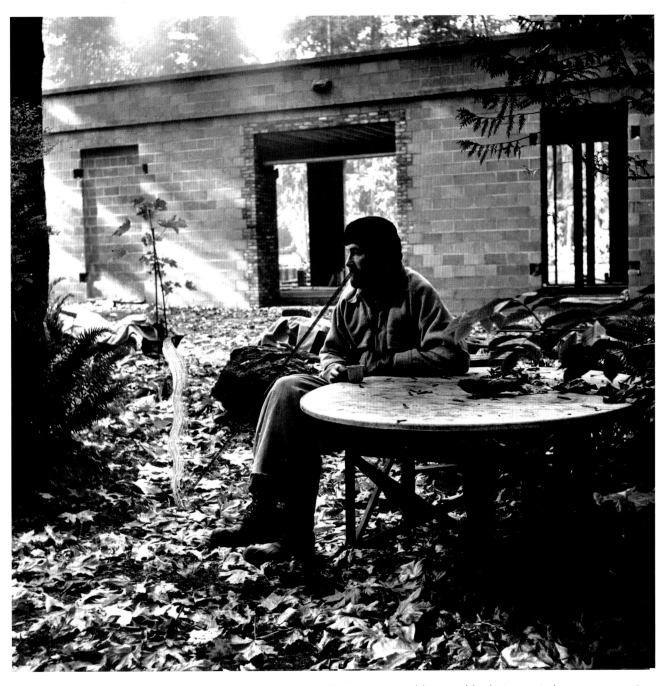

Morris Graves at marble-top table during main house construction.
Graves later painted in pipe and smoke.
(Mary Randlett, October 1949)

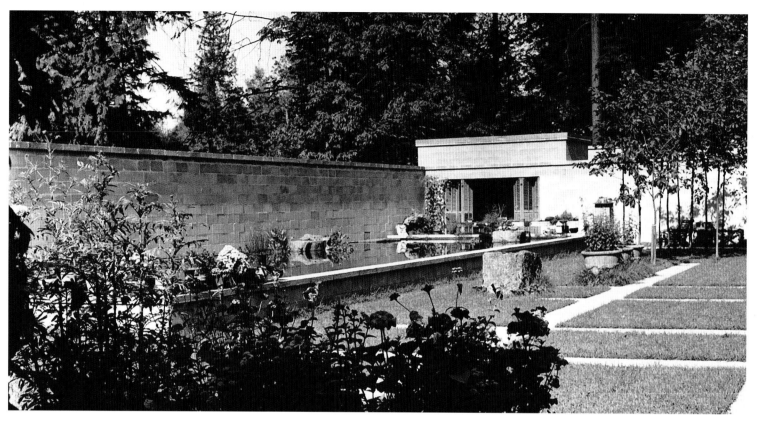

View northeast across portico garden and pond to shuttered pavilion. (Mary Randlett, September 1957)

wall, ten to fifteen feet in height and surmounted by capstones of the same cement block, began to ensure, in no uncertain terms, privacy. The wall began at the storage area of the gatehouse and wended its way west through underbrush and cedars to terminate at the northwest corner of a proposed walled garden. Immediately, Graves planted English ivy, which in the highly conducive northwestern climate would eventually cover the cement block and drape itself on the other side of the wall.

That Graves yearned for privacy is undisputed and the high wall further evinced that desire. It could not, however, exclude the overhead noise of the increasingly heavy air traffic, most of it arriving and departing Seattle–Tacoma International Airport to the south. But for now, there were no thoughts of one day having to forsake Careläden as he had The Rock, and he continued to develop his garden and house under relatively peaceful skies.

Much of the acreage was (and still is) swathed in Oregon Grape (*Mahonia aquifolium*) and Salal (*Gaultheria shallon*), two native plants treasured by Pacific Northwest gardeners. They thrived in and among the native sword ferns and bracken, under the protection of the tall cedars. Graves lovingly nurtured the wild garden areas that bounded the outer edges of the property, and an emphasis on native plants gradually became a signature of the emerging cultivated garden.

Meanwhile, through dint of his single-mindedness and a growing bank account, the main house began to take on its uniquely Gravesian shape. The sketches and notes done so many years previous were incorporated into the final design of the house, echoing what Graves held in his mind during all those years of planning and dreaming. These ideas were first executed in the starkness of The Rock and then at Careläden, where the motifs were resolved and brought to their fullest, most sophisticated conclusion.

The moment came when Graves's design decisions collided with very specific architectural and structural needs. For help, he called upon Robert Shields of the then-premier Seattle architectural firm of Terry, Tucker and Shields. It was not an easy task for Shields, given the pronounced opinions and deep wishes of his gifted client. All the same, compromises were worked out and construction of the main house continued, though somewhat sporadically apace. Another reputed architect, Robert Jorgensen, helped Graves with various structural problems and saw to it that the huge, octagonal columns of cedar were realized and proportionally placed at intervals on the portico, framing the inner courtyard of the house.

Again, the expedient use of large and inexpensive cement blocks was incorporated into the construction of the main house and the building quickly began to rise from its foundations and take final shape, emulating Graves's much smaller and less ambitious island project. Whereas The Rock was poised and enclosed on its brooding mountaintop, Careläden became lighthearted, enhanced by the nine-foot windows throughout, which invited light to flood the paneled rooms.

As row upon row of cement blocks rose, Graves, in a trice, planted Boston ivy on the exterior walls, hoping to cover as quickly as possible the practical but uncongenial cement block façade. In the coming years, the ivy would lose its battle for survival against voracious moles, which thrived on the tender roots.

As the house rose steadily to its final height, Graves set aside his plans for the interior portico garden, at least for the time being. Achieving the goal of roofing the structure was paramount. The beams for the flat roof were eventually put into place, followed by the boarding; the tar was then poured, immunizing the building against imminent autumn rains.

Fortunately, the Pacific Northwest is blessed with a September of sunwashed days, the dwindling warmth allowing one to linger in the open air. It is an Indian summer of increasingly crisp nights, the maples and alders changing color and the pots of chrysanthemums beginning to appear here and there in temporary containers. That September was no exception, providing the extra time required for the doors and windows, which had been ordered months earlier, to arrive at the site. Stacks of fir planking also arrived for use as flooring throughout the house. At that precipitous moment, Graves came into contact with a remarkable Danish craftsman, Mark Jensen, who is largely responsible for the beauty of Careläden's interiors. The quiet carpenter precisely carried out Graves's aesthetic decisions with a large measure of his own Scan-

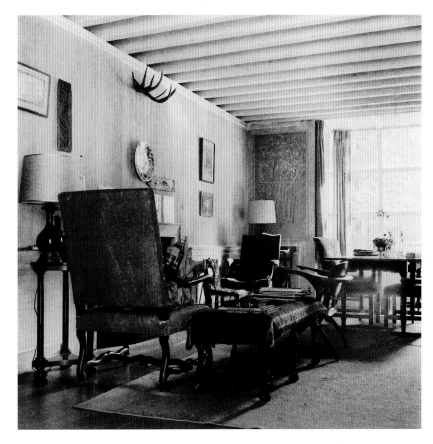

View south through dining room to south-wall bay window.
(Mary Randlett, September 1957)

23

stones

4 blocks
high

saw mill
for 12
for 15. columns

CAP
on

debris for further wall

116

5 6
3/4

10 20

10

0 0 0 0 0

P.O.

KITCHEN

ft
10

BATH

15 0

20 × 30
LIVING

15 × 30
BED

BATH

CLOSET

one wainscott trim
Portico side

increase width by one?

present door

increase height by one block

fixed panel over window

Parapet

increase width and shutter...

SINK

15

0 0 0 0 0

ICO

-4"

20 x 27

Mr. Stone
Dexter 100

X17 4 X 30 HALL

STUDIO

closets

15 X 18

BED

10 X 12
BATH

20 X 8
STORAGE

GARDE

small window door

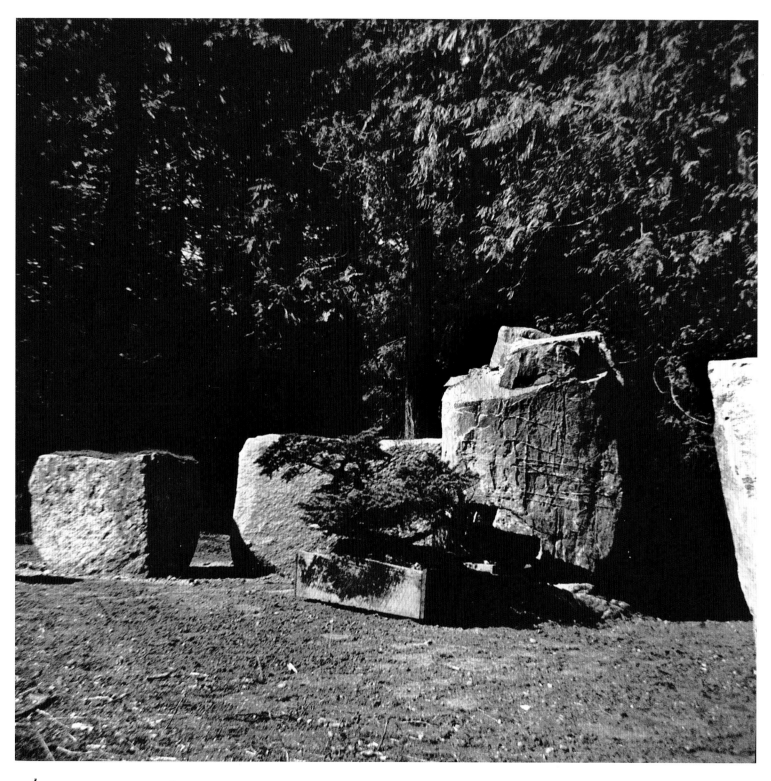

bon sai brought from "timber line" 6000 ft.?
sp.? from above Monte Christo

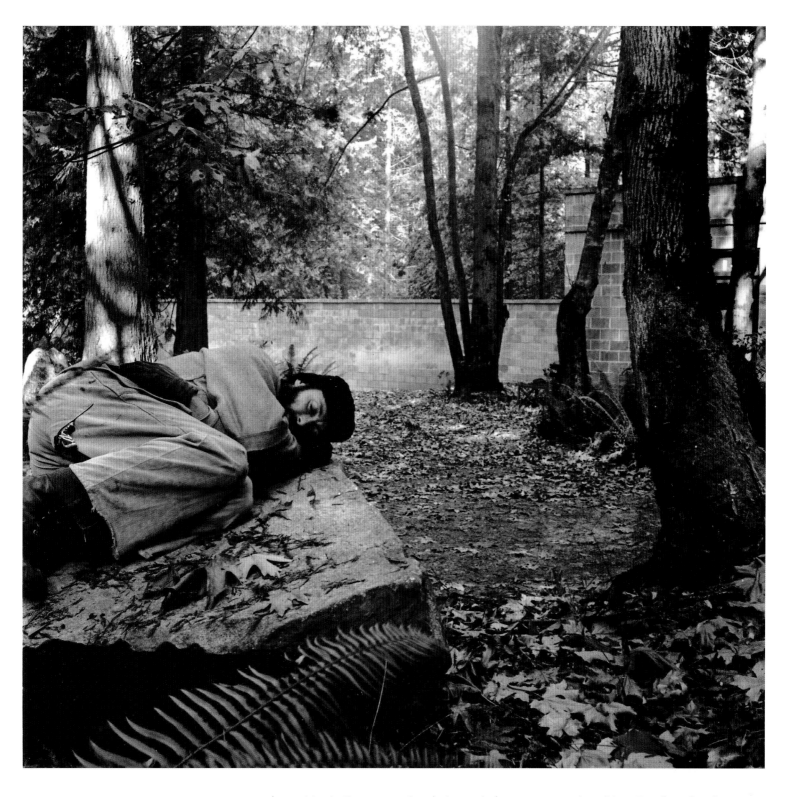

above: Morris Graves napping during main house construction. (Mary Randlett, October 1949)

opposite: Massive stones collected by Morris Graves for Careläden garden. Graves added: "Bonsai brought from 'timberline' 6000 ft? from above Monte Christo," a village in the Cascade Mountain Range, Western Washington. (Mary Randlett, October 1949)

previous spread: Preliminary floor-plan sketch of main house and portico area. (Morris Graves, ca. 1940s)

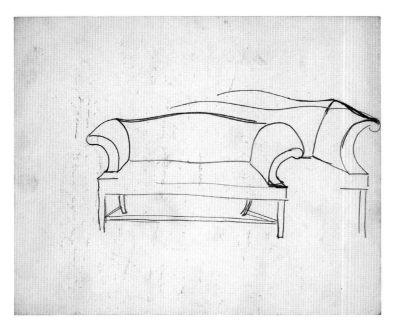

Preliminary design drawing of "Chippendale-style" sofa, by Morris Graves, ca. 1940s.

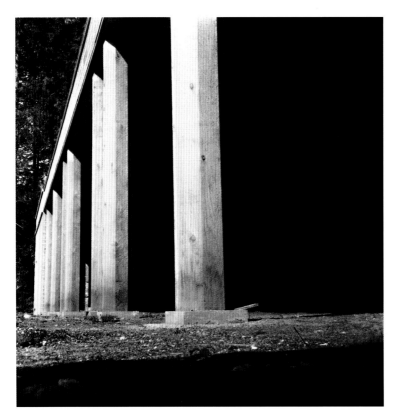

Construction view north toward studio wing from kitchen wing. (Mary Randlett, ca. 1940s)

dinavian practicality. It was a beneficial, even calm, working relationship.

In Mr. Jensen's capable hands, the interior work of flooring, finishing walls, framing windows and doors, building cupboards and counters, and installing complicated French hardware progressed at a steady pace.

One, if not the most, visually satisfying interior element of Careläden is the wood paneling that encases the kitchen and dining-room—the ceilings, floors, and walls. No exotic woods were used, but instead the humble fir of Pacific Northwest forests. A horizontally faced, three-foot-high dado along the lower part of the walls created an elegant surface that met the vertical boards running upward to the fourteen-foot ceilings. The baseboards, interior and exterior doors, and window frames all received the same attention to detail.

When the paneling was completed, we toasted the fir by slathering on a lime mixture, then sanded it by hand, which left a white residue in the grain of the wood. Lastly, the paneling was waxed (also by hand), which gave each room a warm glow, enhanced by low-wattage lamps and candlelight.

While Graves took a break from his construction project to live in Chartres, France, he kept in mind what he wanted to accomplish at Careläden. He haunted the hardware shops of Chartres and Paris, accumulating a huge collection of iron and enamel hardware for the doors, windows, and cupboards: hinges, handles, latches, boxes of mechanisms, and even a typically French exterior bell pull. When installed, the metal rope was concealed in the ceiling of the entry hall, and given a good pull, the bell would resound in the interior courtyard.

The orderly and practical influence of France began to predominate the design of Careläden—the brick-floored drive-through gatehouse, the curving

drive to the graveled court, the classicism of the house's façade, its interiors, and the garden vistas.

Graves's fascination with French, English, and Japanese gardens brought together all three aesthetics at Careläden. His regard for each had specific echoes in the garden and the melding was no more evident than in the distinguished portico/courtyard, with its fourteen-foot octagonal cedar columns. The columns framed the long portico of seventy-five feet, intersected at intervals by oversized cement squares on the gray cement floor.

The presence of the portico is a stroke of distinctive practicality, considering the promiscuous weather patterns of the Pacific Northwest. Often in summer, a warm rain shower would briefly deter gardening and the gardener would take shelter under the towering roof of the portico. Graves planted a clematis montana with the hope that it would drape itself in cascading skeins the entire length of the portico. At first, the vine was plagued by moles, but at this writing it has survived and is healthy, an outcome that would have delighted him. On the exposed old brick wall and at its southern end, Graves was in the habit of hanging in rows various Mexican wooden chairs with leather thong seats. These would be conveniently taken down when needed for guests at the long wooden table, where more often Graves would sip coffee alone on a winter afternoon or he and I would enjoy a late evening repast as the summer sunset lingered in the windows.

Nine double doors opened on the portico, each nine feet high, eight of them glass paned and the ninth paneled. The ninth door was the entry to Graves's studio at the northern end of the portico. Immediately to the left of the door, Graves painted in oils a remarkable still life of an elongated table upon which sits a slightly distorted Chinese bronze urn holding a bouquet of flowers. It remains untouched by weather to this day.

The large studio space is exceptional for its light, both windowed and sky lit. Open shelving held the delicate

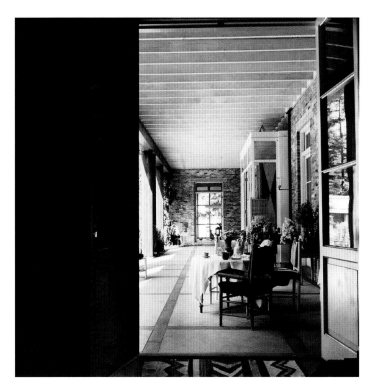

View north from dining room through covered portico to studio wing. (Mary Randlett, September 1957)

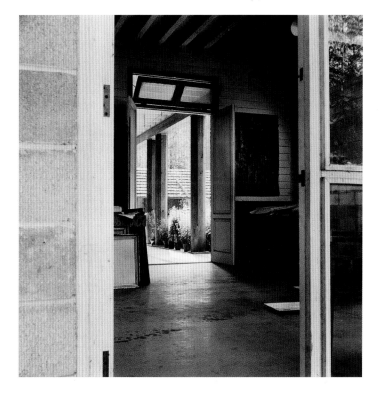

Southeast view through studio to portico with kitchen wing in the distance. (Mary Randlett, September 1957)

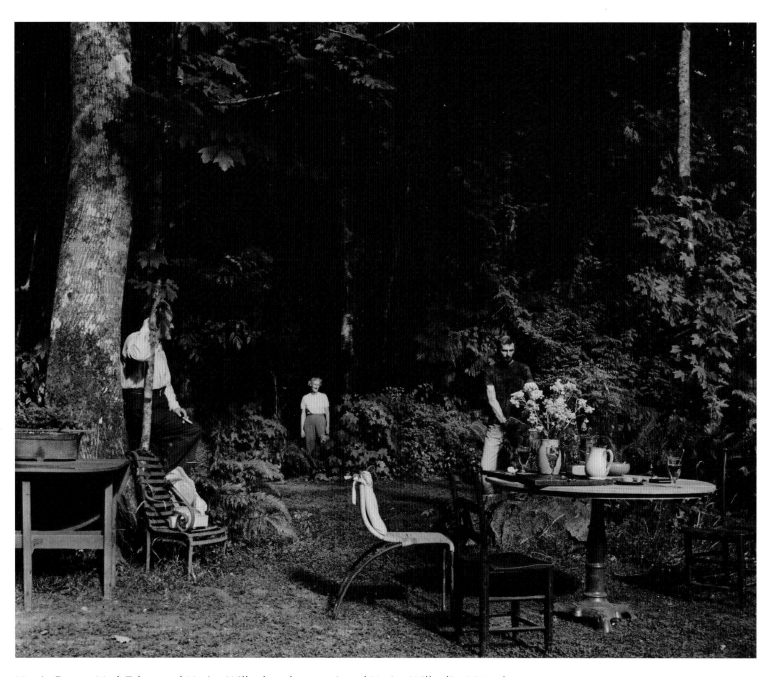

Morris Graves, Mark Tobey, and Marian Willard on the occasion of Marian Willard's visit to the
Pacific Northwest. Willard was then sole dealer of Tobey and Graves. (Mary Randlett, ca.1950)

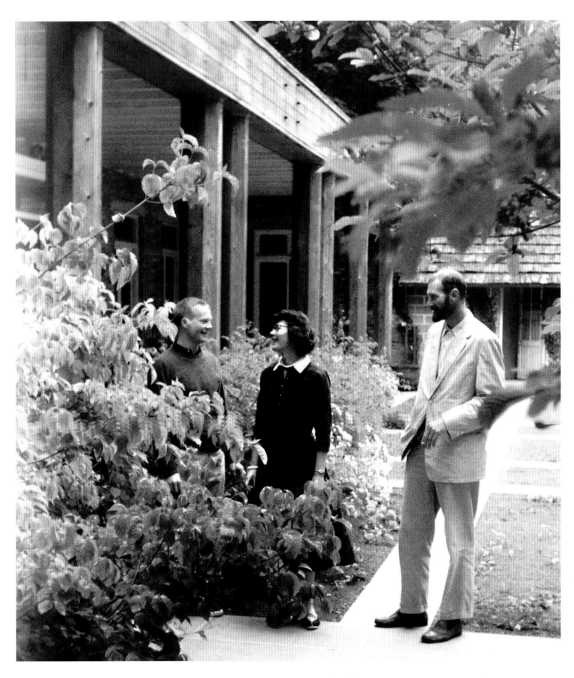

Richard Svare, Betty Graves, and Morris Graves
in portico garden, kitchen wing on the right.
(Wally Graves, June 1957)

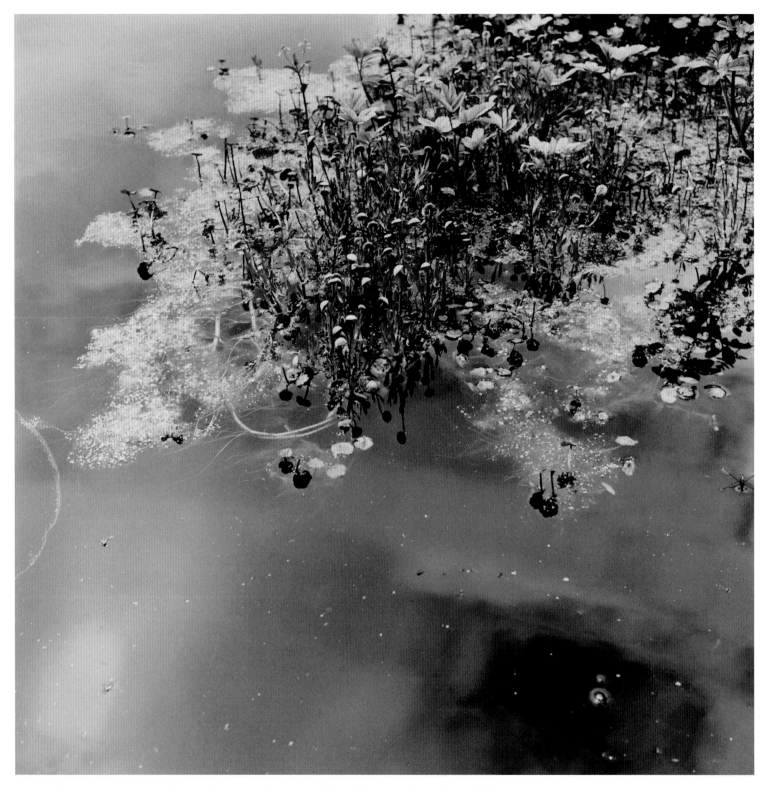

Detail of portico pond, natural still life with native plants. (Mary Randlett, September 1957)

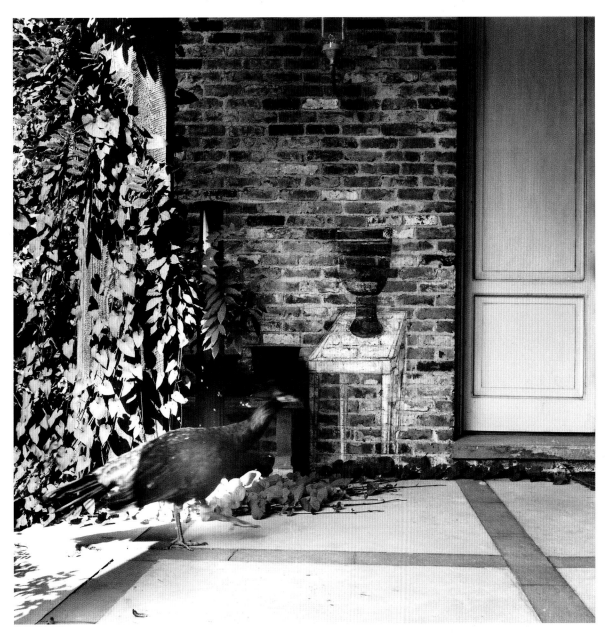

Noisesome peafowl on daily promenade in front of oil-painted still life,
by Morris Graves, of elongated table and Chinese urn with flowers
on north wall of portico, paneled door to studio on right.
(Mary Randlett, September 1957)

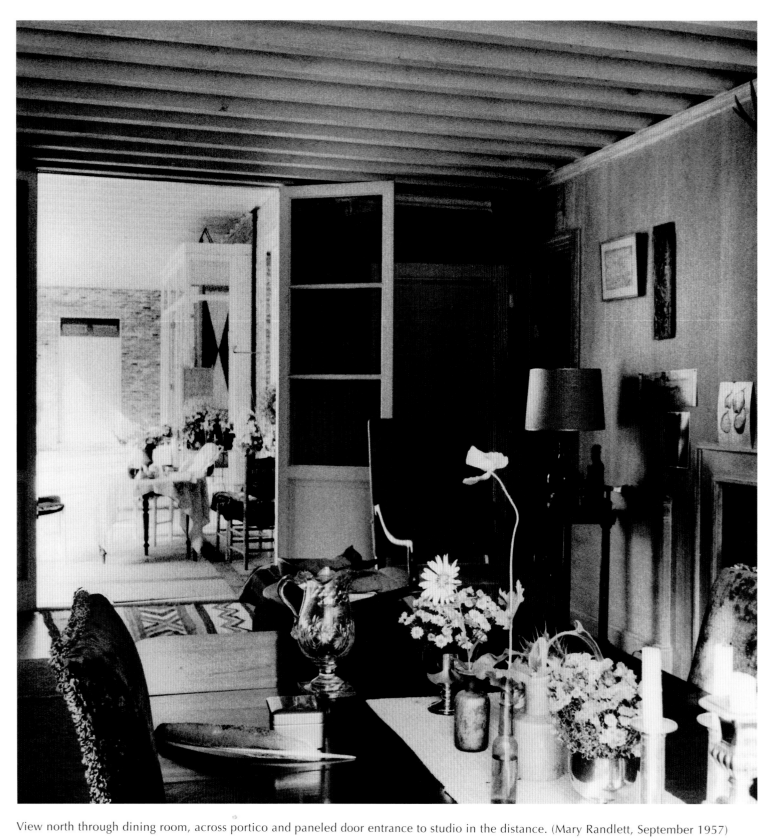

View north through dining room, across portico and paneled door entrance to studio in the distance. (Mary Randlett, September 1957)

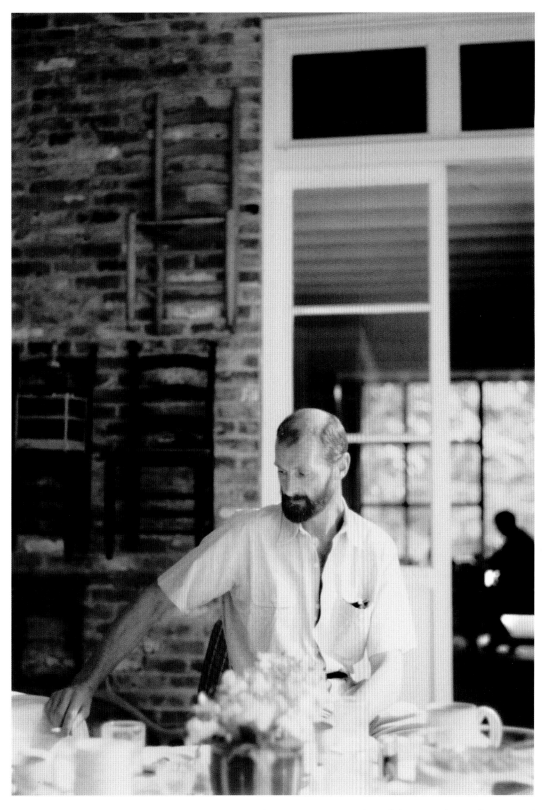

Morris Graves in portico with view into dining room to south wall bay window, silhouette of Richard Svare in the distance, Mexican chairs on wall to the left. (Eliot Elisofon, 1957)

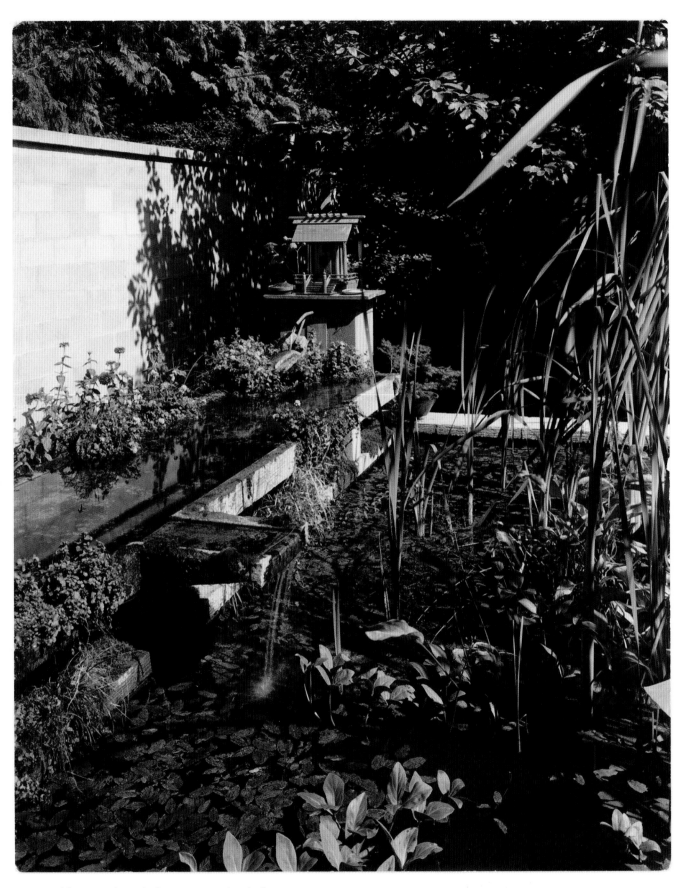

Water table at north end of portico pond. (Phyllis D. Massar, ca. 1953)

Japanese and Chinese rice papers he so frequently used, jars of brushes of various sizes and shapes, boxes of paint tubes, bottles of tempera. His paint-spattered worktable was of ample size, and leaning here and there were empty canvases, works-in-progress, as well as earlier completed paintings. A tall stool stood beside an easel and an old, tattered upholstered chair squatted beside a camp bed and near the windowed wall of a small, sheltered courtyard. The small yard was enclosed by three very high walls, which provided Graves with complete privacy for his work.

The hours he spent in the studio were variable. By the heat of the large, black wood stove, he would work late into the night and even into the early morning hours, when the infrequent nocturnal cadences were sympathetic to his concentration. Now and again, the stillness would be broken by a burst of Shostakovich or a sustained legato from Mahler. During the daylight hours, I would leave a tray of food outside the studio door with a knock to let him know it was there. In Graves's brief interludes from painting, I could find him weeding the herbaceous borders, cleaning the ponds, planting ivy, or pausing to rest on a bench with the inevitable cigarette in hand.

It was an artist's workspace, roomy, every inch of it utilized. The white walls held works-in-progress, scraps of notes, a phrase from a poem, perhaps a new idea or a promising title pinned to the wooden surface.

The garden of the portico in part replicates the intersected floor of the portico, with meticulously groomed lawn contained within the squares of cement paving crafted on-site, in varying sizes. A few chestnut saplings formed an intimate copse that shaded a curved iron bench.

The variegated squares frame at ground level the great oblong pond approximately forty by twenty feet in width. A raised wall, with capstones at seating level, borders the pond on three sides. The fourth or western side of the pond is backed by a continuous high wall that, in turn, was shaded by a row of fledgling chestnut trees, which Graves cultivated from nuts he pocketed while touring the grounds of Versailles during his time in Chartres.

The pond is the obvious focal interest of the portico garden and rightly so. Its water reflects scudding clouds, gray skies, and clear blue heavens; during rainfall, the pond comes alive with dancing rings that

Detail of portico pond, another view.
(Mary Randlett, September 1957)

37

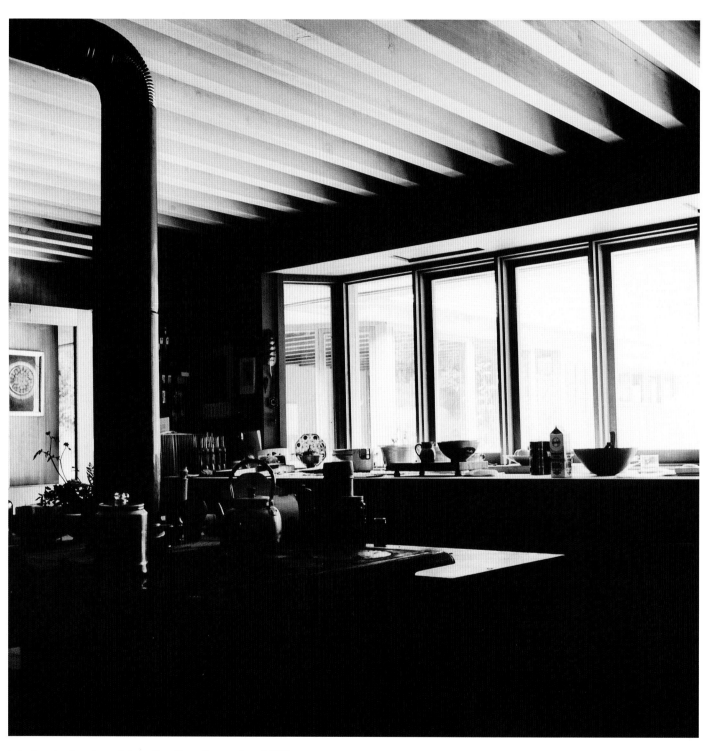

Interior studio view. (Mary Randlett, September 1957)

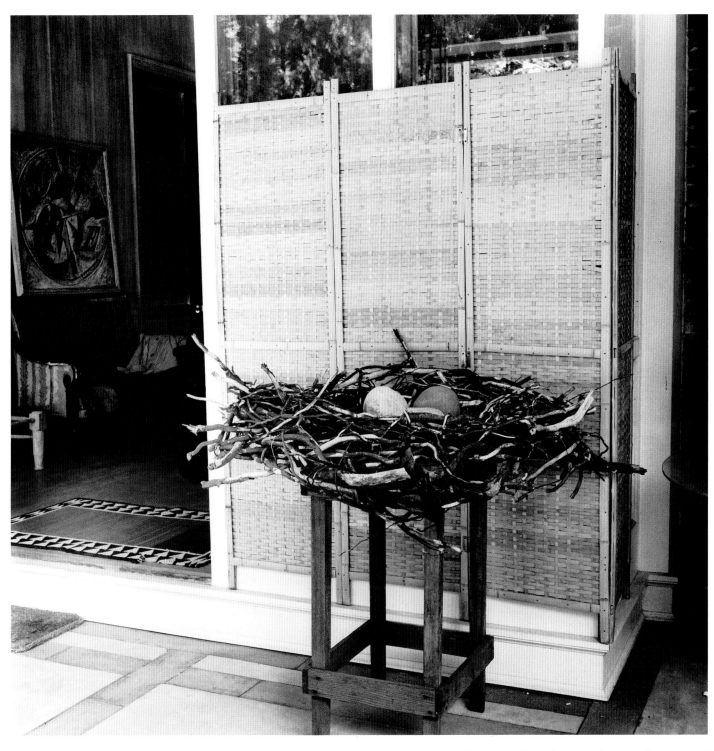

View east from center portico into entrance hall area, right of center floor to ceiling glass panels, partially screened with standing sculptural still life of natural materials, by Richard Gilkey. (Mary Randlett, September 1957)

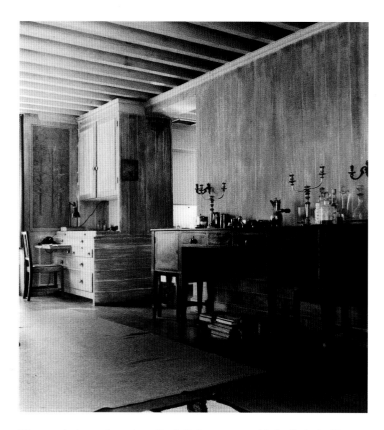

Diagonal view of west wall of dining room with built-in buffet, kitchen entrance, and kitchen bay window.
(Mary Randlett, September 1957)

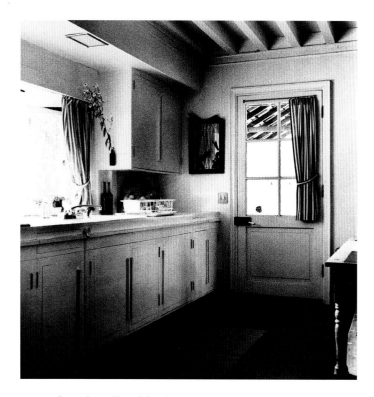

View of south wall and kitchen bay window across to west wall and door entrance to woodshed.
(Mary Randlett, September 1957)

scatter across the surface of the water. Graves planted papyrus at one end, intermingled with white lily pads. Rising out of the water are two spectacular stones, mighty in their stature and impressive in their sheer age. Their origin is unknown, but the Olympic mountain peaks, which border Puget Sound to the west, are a likely source. When the moment came to place these hoarded denizens in the pond, Graves was helped by the artist and friend, Richard Gilkey. The stones rest on large plinths, their girth half submerged in the dark water. To draw the conspicuous comparison to a watery Zen garden would be too facile, but the calming effect of the stones is undeniable.

At the pond's northern edge, Graves designed and built a water table. It sits slightly above the pond so that the constant flow of a thin trickle of water splashes into the pond. Small water plants sit in the shallows of the table and with time, moss and algae would create a wet patina on the entire table and the stones below.

Opposite the water table is a small building that Graves called "the pavilion," which became a favored retreat. There he napped or meditated, listening to the water gently dribble into the pond. To shield the light, a pair of antique green shutters was placed at the opening of the pavilion.

Directly behind the retreat grew another small walled garden that Graves intended to make into a greenhouse but never did. At the opposite end of the portico garden, a door led to a narrow hallway that served as a passage to the dining room and kitchen.

On the back wall of the garden, a tall, narrow wooden door, framed by columns of cement block and surmounted by two iron urns, led down to the service drive and the "lower forty" garden of vegetables, salads, and two young apple trees. Opposite was a commodious wire-enclosed coop for a bevy of large, reddish laying hens and their valuable rooster, as well as a few colorful and dainty bantam chicks. Later, Graves added a pair of peafowl—a speckled white female and her vibrant mate. They roosted

high up on the cedar boughs opposite the main entrance to the house and were assiduous "watchdogs," shrieking whenever a car approached the gatehouse. Several raucous guinea hens completed the menagerie but sadly for Graves, they proved too noisy for the neighbors, even for some who lived blocks away. With regret, the honorable artist gave them away. He delighted in the haunting cries of the peafowl and their daily promenade through the house, stopping to admire themselves in the mirror set up specially for them.

Attached to the kitchen was an open-sided woodshed where chopped wood for the two working fireplaces and studio stove was stacked. The great lawn immediately began, and the immense herbaceous border along its westerly edge was cultivated to one hundred feet in length. Closely packed flowering plants were arranged according to height: Poor Man's Orchard, Delphinium "Blue Jay" (*Delphinium elatum*, Larkspur), Mexican Aster (*Cosmos bipinnatus*), Lemon Lily (*Lilium parryi*), Cornflower (*Centaurea cyanus*), and at that point Graves's notations, alas, become illegible.

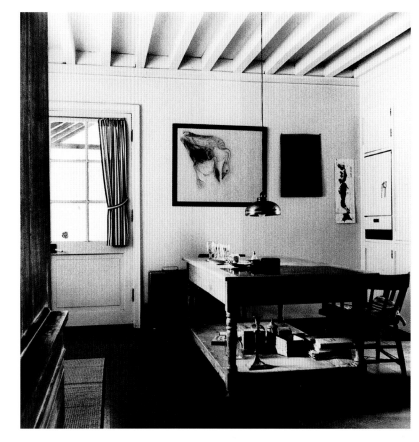

View of west wall of kitchen across old pine table on which Morris Graves's still-life arrangements have been created on top and bottom. Above the table is a Morris Graves drawing of two geese. (Mary Randlett, September 1957)

One dog day of the summer of 1953, the house was finally ready. The kitchen, with its white-painted wood and deep-silled bay window, filled with light. The stove and oven were in place, the small refrigerator was at eye level, the dishes were in the cupboards, and the French cutlery in drawers. A door lead to the woodshed outside. We could cook and take meals in the new house for the first time, either at the old pine table or in the adjoining dining room.

A pass-through, at counter height, from the kitchen to the built-in buffet in the dining room proved handy, and a sliding door disappeared into a wall when there was no need to close off the kitchen. The dining room had a large projecting bay window with a bench that overlooked the great lawn and provided extra seating for the dining table. At a right angle was a mantleless fireplace, and on the wall above hung the large, mysterious oil painting, "Guardian," a giant, intimidating bird of prey flouting a threatening set of horns that sprouted from its head.

Unknown to anyone for years, except Graves, was a very small hidden drawer inserted into the side of the buffet, placed high up by the beams of the ceiling. A person of average height would need a ladder to see the drawer, let alone open it. Graves, being 6'4", could easily reach the drawer and pull out a chocolate bar from his stash of sweets. It was a gesture typical of Graves at his most playful.

On the opposite end of the dining room, paned double doors opened on the portico. Another door led into a small sky-lit hallway with built-in cupboards and bookshelves. A farther door went to a bedroom with a huge

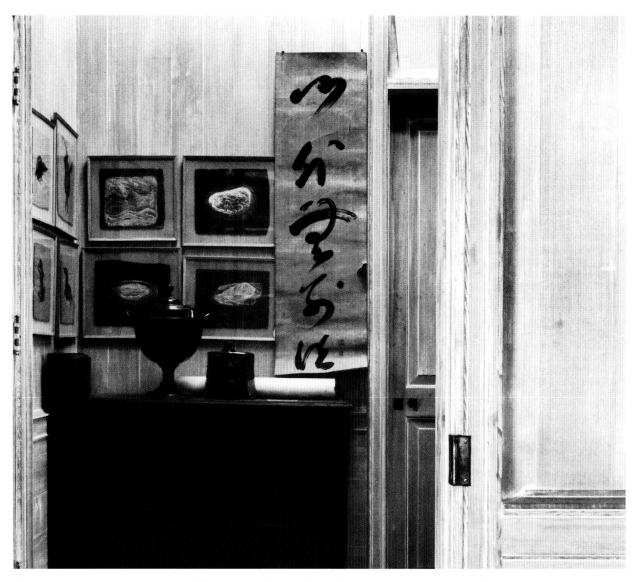

View east from northeast corner of dining room into skylit hall leading to guest bath and bedroom.
(Mary Randlett, September 1957)

window divided into large sections and, like the dining room, that room overlooked the lawn, herbaceous border, a grove of airy vine maples and in its season, a drift of luminous snowdrops. One wall was devoted entirely to a built-in closet. Contiguous with the closet were a bath with tub and separate shower stall, a wash basin, and toilet. Both rooms faced the entrance court and the windows of the French doors were covered, as were all the doors fronting the court, with black and white striped curtains.

As with all the rooms of Careläden, the large living room was paneled, and the mellow color of the walls, the twelve-foot ceilings, the tall windows, and the color of the painted floor made the room and its furnishings not only personal but romantic and provocative. The mantled fireplace became the center of gravity for the room. Ivory and ebony-black marble in geometric shapes decorated the surround of the fireplace. On the ceiling above the fireplace, Graves painted a black elongated oval, which perplexed many visitors: was it a fathomless black hole, was there a mystic significance, or was it a symbol? Graves never bothered to explain and some questions are undeserving of an answer. As Gertrude Stein replied when asked if she had anything to say about modern art,

View east from southeast corner into guest bedroom. (Mary Randlett, September 1957)

"Yes, I do. I like to look at it." One could like to look at Graves's black oval and can continue to do so, as it remains where he painted it.

In subsequent years, Graves would acquire several key pieces of furniture for the living room. He knew exactly what he wanted: two Chippendale-style sofas covered in blue velvet with large square footstools of the same blue velvet and two long tables in back of the sofas, with lamps on each table. Two 18th-century Japanese screens hung on opposite walls. A disguised cupboard to the left of the fireplace held a record player and records, a collection of flower containers, and found objects. Olive-green silk curtains hung at the tall windows, which could be pulled aside into recesses of the paneled wall. A large beige cotton and silk carpet covered the center of the room.

The painted fir floors of Careläden are an unusual color, which Graves had first seen on the floor of a French country schoolhouse. Thanks to his unflinching memory, he was able to reproduce the ochre-like hue himself, which he would come to use in later houses. A pair of paneled doors opened on the entry hall and faced identical

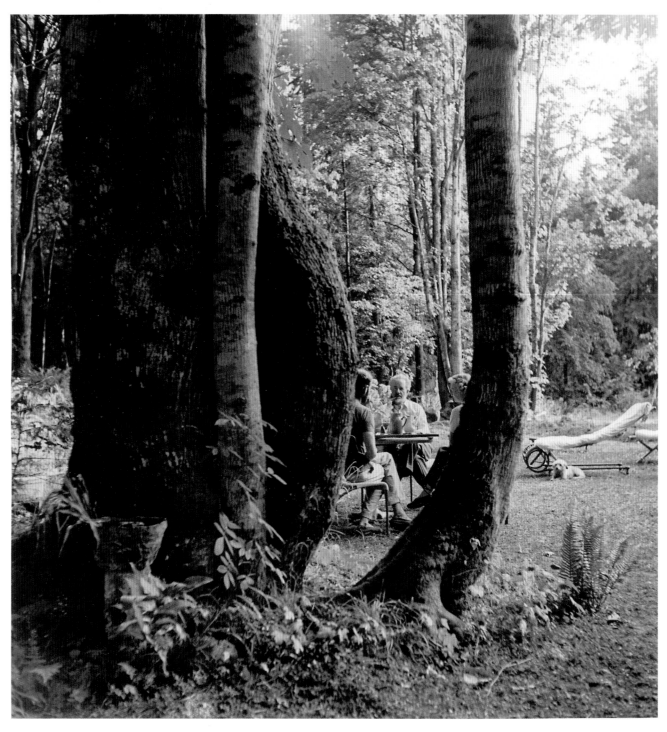

Morris Graves, Mark Tobey, and Marian Willard. (Mary Randlett, ca.1950)

doors opposite the master suite. Even the hallway resembled a sunroom, as light flooded the suite. The windows and doors to the portico went from floor to ceiling, as did the two long windows that flanked the front door. A round mahogany Empire table, split into two sections, stood in the center of the hallway. On the two walls, Graves hung three gold-washed Japanese paper panels on which he had painted his favorite poor man's orchids.

Notwithstanding that Careläden was his home, the northern wing of the house belonged exclusively to Graves: his studio at the far end was, in a sense, sacrosanct and rarely, if ever, was a visitor invited into the studio. When so inclined, Graves would stash away his work-in-progress and there would be little to indicate that he was actively painting.

His bedroom and bath were adjacent to his studio, which made for easy ingress or egress if an unwanted visitor appeared at the front door. A long hallway, facing the portico and often curtained, closed off the bedroom and bath. The bedroom was sparse: a large mahogany bedstead with fur cover, a souvenir of his wintry days in Chartres; a fanciful chaise, a gift from a friend and never

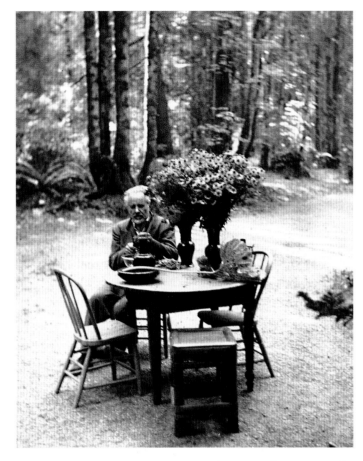

Mark Tobey, on a rare foray into the countryside, an environment he avoided assiduously. He is shelling beans for supper. (Mary Randlett, ca. 1950)

used; a table and reading lamp; and a wall cupboard for clothes. Nothing more, nothing less.

Despite the halcyon days of thoroughly enjoying the completed house—entertaining his closest friends, working in the garden, taking the occasional drive north to meander through the small rural towns of the Skagit Valley or British Columbia—an uneasiness crept into Graves's life at Careläden. There were signs of changes to come in his secluded corner of the woods. The empty acreage adjacent to Careläden was sold, and there were rumors of a house to be built. At the southern and eastern borders of the property, the prospect of additional houses meant that cedar and fir trees would be felled and the impenetrable screen of privacy would be gone forever. Visions of bulldozers carving out the forest, with their rumbling, splitting engines, only amplified the vexation welling inside Graves. Worse, the overhead droning and whining of airplanes began to intrude on Careläden's serenity. Ironically, it would again be aeronautical aggravation that would compel him to leave his home.

Caution made Graves rethink his plans to bolt forever. We decided to spend a year in rural Ireland, a country he instinctively knew would be a world away from "machine age noise." He was aware of Ireland's status as a by-passed, nonthreatening nation. It wasn't a world power and was not likely to become one.

After spending one year in Ireland, we returned to Careläden, determined to sell and relocate.

The weeks preparing to depart forever were a mixture of deep feelings and some misgivings, accompanied by the realization that all of the back-breaking work, the time and energy and, above all, the love he had

Morris Graves with his dog, Edith. (Mary Randlett, August 1949)

invested in Careläden were not wasted. He genuinely believed he had created a worthwhile homestead, full of beauty and wonder. All the same, endowed with a rare ability to move on, he knew in his heart of hearts it was time for a change.

Truth be told, Graves was constantly on the move, if not physically, mentally. His peripatetic nature allowed him to freely travel with a minimum of angst. Yet he treasured the extended times of total solitude in his own environment: in his house and his garden.

Postscript

Coyotes are rarely, if ever, heard at Careläden and environs these days. When Graves lived there, their yips and barks could be heard at sunset in the neighboring woods. The dewy early morning rambles of deer on the lawn are gone as well, and one wonders to where they have retreated. Now the dusty roads are sleekly tarmacked, the lanes are groomed with edges of clipped lawns, and security gates are becoming more visible.

It wasn't always so, but then, what remains the same?

Careläden, having had several owners since the initial sale in 1957, still sits elegantly on its plane, surrounded by more ivied walls. The portico garden pond thrives with colorful koi, the great lawn remains, and two friendly dogs make it their playground. The paneled rooms are all the more mellowed and perhaps on some moonlit nights, faint echoes of joyous laughter can be heard, or perhaps a phrase of Vivaldi coming from Graves's studio, or even a muffled bark from his small, beloved dog, Edith.

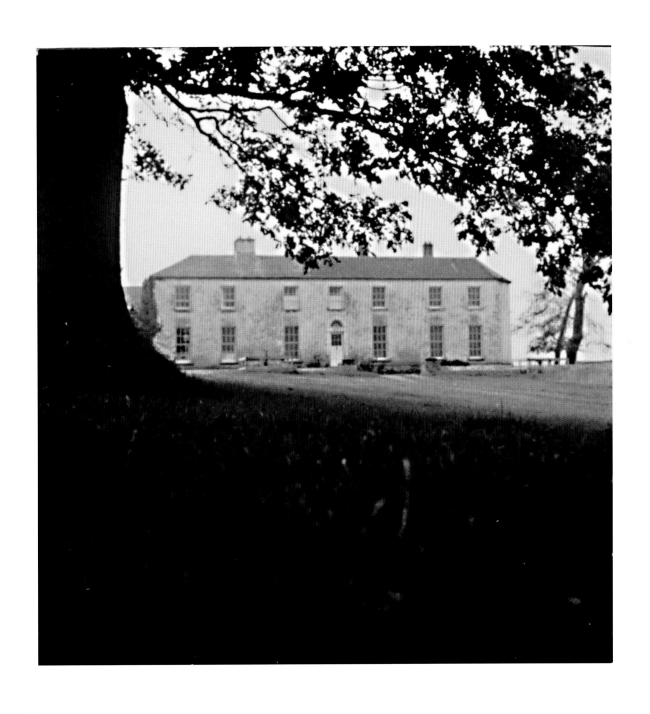

Woodtown Manor 1958–1964

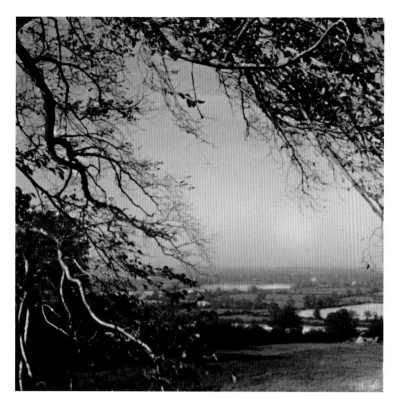

In Ireland, where the "Great Cart" (as Graves referred to Old Eire) can be bogged down in mire, the rain-emeralded landscape is littered with ghosts of gardens surrounding irretrievable remnants of once-grand houses. These derelict structures and their gardens murmur of a lost grace, never to return. Reminded of Yeats' words, how in the span of a few fleeting years "beauty passes like a dream," Graves and I caught our first sight of Woodtown Manor, its house and gardens reflecting a dispirited and sullen aspect, grievously unloved for many generations. We somehow knew that we could bring alive this sleeping beauty, and though beset by our initial romanticized vision, we had few illusions of how daunting a task it would be.

Lingering over the landscape is a sense of "premature nostalgia," cloven by a sadness overlain and infiltrated by a sweetness, not an uncommon lineament in many countries. For instance, in Norway—Ireland's baleful marauder in those mist-laden, ancient days—the "sadness of the North" is conditioned by its grieving and lovely physiognomy. Greece has its *kaimos*, a honeyed lamentation echoing its wearied and agéd history and its rocky, fearsome, wondrous countenance.

above: Vale of Dublin from Woodtown Manor. (Dorothy Norman, 1962)

previous spread: View west of Woodtown Manor House.
(Richard Svare, 1959)

We were preconditioned to respond to Ireland, anticipating the melancholy that so pervades it and the reminiscence that awaited us. We were temperamentally suited to live in that greening and by-passed land, a world away, in its history and character, from the fledgling Pacific Northwest.

Our tires flattened the tall grass as we negotiated the barely discernible lane toward Woodtown Manor. We parked the car and walked through the gently rolling fields to the house, only to be greeted by placid cows peering out of gaping windows of a first-floor room of the once-genteel manor.

We chased away thoughts of rejecting the house, which arose upon meeting those bovine eyes, inured as we were by previous years of living in Ireland. Instead, we rented a large house in southwest County Cork and meticulously explored the region, coming upon ruined, bat-riddled castles and

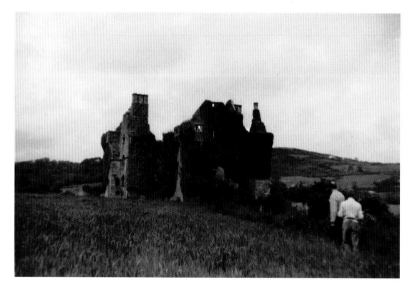

Morris Graves and Richard Svare exploring ruined house, County Cork, Ireland. (Dorothy Schumacher, 1954)

50

their watchful, silent owls. We visited a plentitude of forlorn and abandoned 18th-century Georgian country houses inhabited by thin, wiry cats and fantasized about the possibilities of renovation. We went so far as to seriously consider purchasing the rather knavish (as it was considered in its vainglorious heyday) ivy-choked castle known by the outlandish name of Castle Freke, after the family who built the now-ruined pile of timbers and stone.

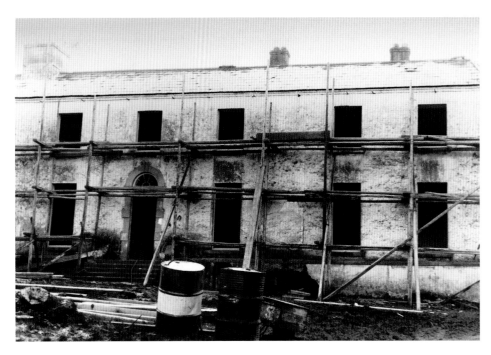

Scaffolding on front façade. (Richard D. Gavin, Dublin, August 1959)

All the same, the walls of Woodtown Manor were intact, some windows were paned, the slate roof held only a few gaps, and the outbuildings were in good repair. The compound sat on a slight plateau, surrounded by a checkerboard of greening fields that sloped downward to the Vale of Dublin. The views of Dublin were splendid and to the west, the eye could perceive the lush county of Kildare and on a "pet day" (clear and sunny) still farther afield.

South of Woodtown Manor are the Dublin hills and Wicklow Mountains, and directly above, in a prominent position, are the desiccated ruins of the infamous 18th-century Hellfire Club—a gathering place for the rakes of the time, who indulged regularly in all of the Seven Deadly Sins. The covert is beset by a redoubtable mood, which encourages hurried passage on foot or in a car. Above and beyond is the vast expanse of bogland known as the Sally Gap. There, Graves would spend hours listening to the breathing silence of the moor, the occasional ping of a peat shovel digging out the ancient blocks, and the ever-present cawing of jackdaws. It was, for him, a fine place to settle.

On closer examination of the Manor's proposed living spaces, it became abundantly clear that a major renovation would be necessary. The main house had never known electricity or plumbing, let alone central heating. We engaged two local architects, Michael Scott and Patrick Scott (no relation to each other), to examine the house for structural soundness. It was determined that the Manor was built in 1750 of cut stone and brick, and was deemed "in satisfactory condition."

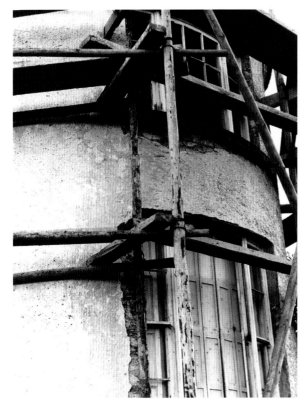

Scaffolding on bay window, first and second floor. (Richard D. Gavin, Dublin, August 1959)

51

Drawing by Morris Graves, early sketch for Woodtown Manor,
pencil on paper, 8.187 x 10.437", ca.1956.

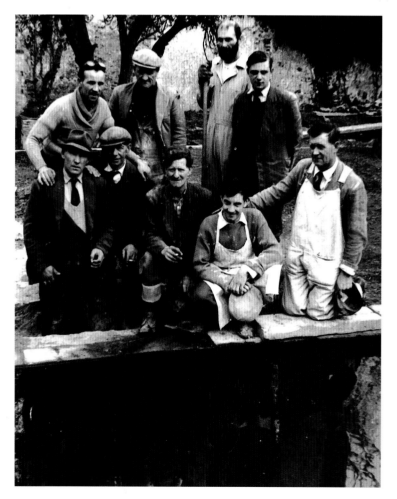

Morris Graves with crew during restoration of
Woodtown Manor. (Richard Svare, 1958)

In the best of Irish tradition, the sale of the Manor was a complicated procedure involving endless talk. The acreage, some fifty in all, untilled for several generations and now grazed by cattle, was entailed in various dowries of the present owner's family. These, of course, had to be satisfied and eventually papers were signed, monies handed over, and the transaction sealed by a great slap of a handshake followed by gregarious toasts with Irish whiskey.

After the purchase, we moved from the County Cork house to the top two floors of an 18th-century house in Dublin, in one of the grand city's renowned quarters, No. 58, Fitzwilliam Square. Dublin possesses several intact squares designed and developed during the 18th century. Each has an iron-fenced garden and a few are thickly wooded with paths ideal for a leisurely ramble. For the most part, the squares are bordered on four sides by rows of stately brick houses adorned with gleaming brass door handles and knockers, kick plates and bell-pulls on heavy painted doors surmounted by the inevitable fanlight windows. Fitzwilliam Square is atypical in its Dublin character and offered hints to Graves for the future garden and the exterior and interiors of Woodtown Manor.

From Fitzwilliam Square, we could easily explore the varied pleasures of Dublin with its profusion of dusty antique shops and auction houses from whom Graves would eventually furnish the rooms at Woodtown Manor, when 1950s prices prevailed. Fitzwilliam Square also served as a base for us while the Manor was being renovated. We daily drove the ten and some miles southward to the district of Rathfarnham, where the Manor is situated.

In early 1958, we began the renovation in earnest,

a simultaneous two-pronged effort: developing the gardens and restoring the interior and exterior of the main house. Graves wrote to his younger brother that the "old garden proves not to be enough—I had to make a lot of it new, new walls but also a maze of new drains in the fields to dry out the house."

The brief communication belied the rather protracted work schedule. The Irish work ethic is relaxed, almost Mediterranean, and Graves was learning patience as best he could. Scaffolding was constructed to repair and restore the old plaster, which concealed the brick underlayer, and to repair and renew the window frames. As much of the original woodwork as could be salvaged was set aside to be incorporated with the new. Miraculous-

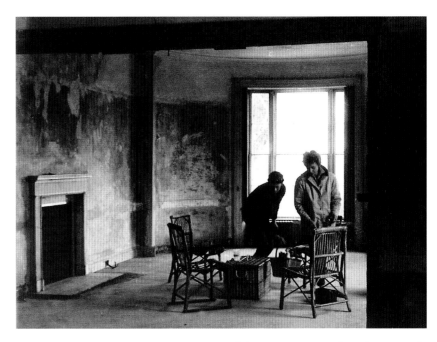

Interior of drawing room ready to be painted,
Richard Svare and neighbor, Polly,
(Photographer unknown, 1958)

ly, the original 18th-century front door was serviceable, with help from a carpenter who realigned its hinges and paneling. The door itself was unusual, as Graves would later learn. Half of the door was paned glass, rarely seen in Irish country houses of the period but perfectly appropriate for the modesty of Woodtown Manor.

With the exterior repairs continuing, the interior renovation went ahead. The placement of the existing rooms would remain the same and plumbing would be added in the kitchen and baths, including circulating hot water, central heating, and toilets. Electrical installation also began throughout the house, including in the projected studio space and around the exterior, where desirable. The Long Barn would have minimal electricity.

As the exterior and interior work progressed, Graves, with his customary eye for detail, began to draw up the garden and landscaping plans that had been percolating in his mind since first exploring those neglected areas. Some two hundred years had passed since the original gardens were laid out, and in recent years they had been beaten down by grazing cattle. When the seasonal rains arrived, the gardens became a sea of squelching mud, where hooves had churned manure and debris

Front entry hall with view into inner hall and staircase.
(Richard Svare, 1958)

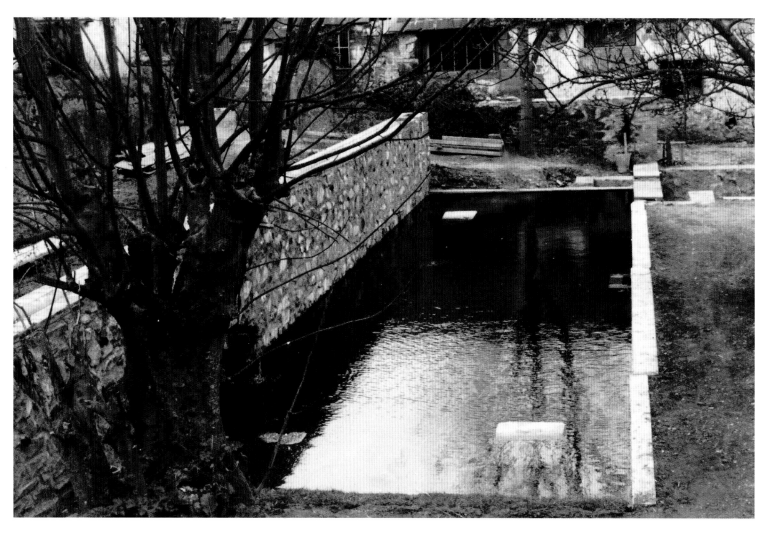

Pond during construction. (Richard Svare, 1958–59)

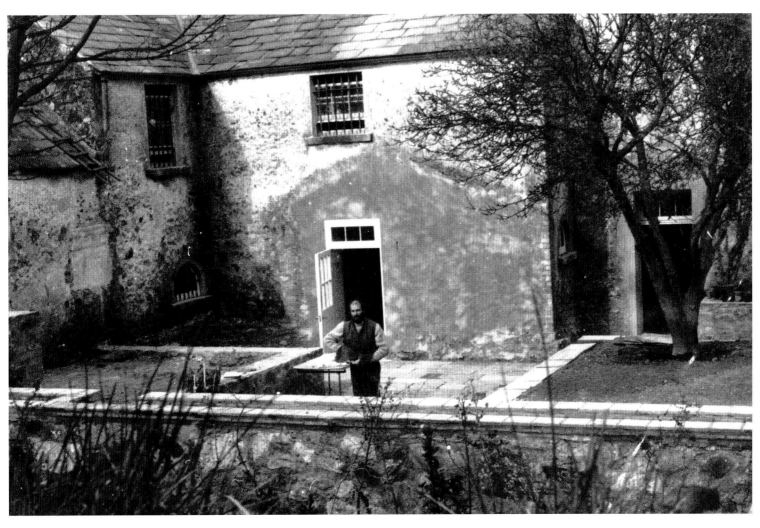

Morris Graves on terrace. (Richard Svare, 1958–59)

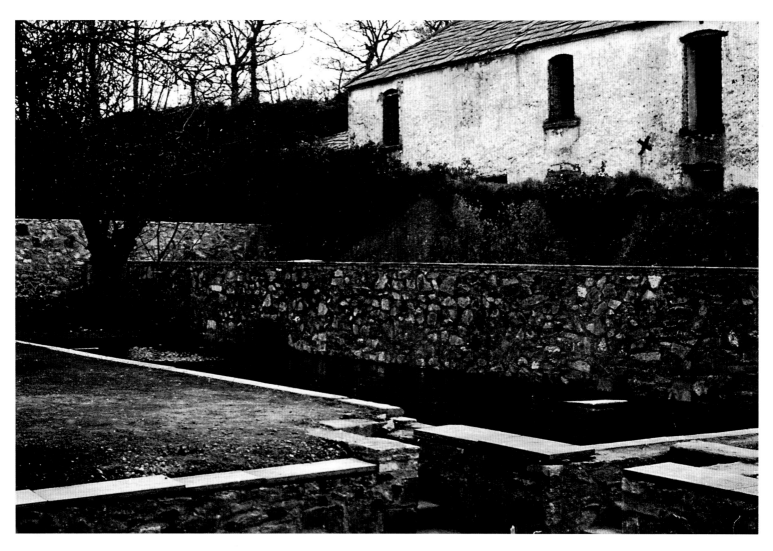

View southwest from terrace across pond and raised herb garden toward the Long Barn, upper right. (Richard Svare, 1958–59)

into the soil. It was a formidable task not only to clear the spaces but to exorcize the disorder.

Graves felt strongly that because Woodtown Manor had been a working farm, the gardens should reflect this venerable and honest purpose. There was never a desire to pretend it was anything but a plain, gracious compound. Pretentiousness was out of the question, so even as the walled-in gardens assumed an orderly mien, it was with a style that befitted the dignified, neoclassic house.

Gradually, the weeks turned into months and the days brought incessant rain, then crisp, frosty mornings when the garden soil crusted over. At long last, birdsong returned to serenade our work, and finally the days filled with brief summer sun that dried the old timbers and the fresh cement, and inspired the newly planted garden to thrive. The house and studio, as well, began to come alive and each lost its crippled, dolorous look.

A smooth cement floor was poured throughout the ground level, accommodating the iron radiators for the central heating. New exterior doors, replicas of the singular front door, were anchored, windows installed, and shutters repaired. The scaffolding erected to repair the exterior walls came down, and the restored slate roofs were ready to either whisk away rain and sleet or shine in the afterglow of summer sun. The house and studio were closed in and snug.

The carpenters began to restore the interior woodwork and the winding curves of the inner staircase, and new mantles and hearths for the three fireplaces were installed after the ancient chimneys had been rebuilt. Kitchen cabinets were constructed on-site and left open, to be curtained later. The plumbers and electricians, thankful to be working indoors, modernized the inner workings of the kitchen and the master and guest baths. Miles of electrical lines were snaked through the inner walls and finally, light switches and outlets were shrewdly positioned.

After each room, upstairs and down, was deemed ready, I painted it. Walls, ceilings, windowpanes, frames, and shutters were given bone-white coats, as were the low iron radiators beneath each window.

At one point, to ensure the plumbing was in working order, and with appropriate ceremony, the taps in the master bathtub were opened. In the kitchen below, Graves crouched beside the main drain in the floor, only to be sprayed with gushing water. As a questionable prank, one that was retold in the local pub on many a dank Irish night, one of the plumbers had crammed the connecting pipes with debris so that the newly laid kitchen floor would be flooded. The culprit could have a hearty laugh with his mates as he regaled them of his feat.

Developing the walled gardens reached a turning point when the formal pond in the main core of the garden was dug, lined, and filled. A second pond in the upper walled garden was a natural pond, fed by a stream, and it became a seasonal haven for a family of ducks "just visiting" on their way to Iceland for the summer or southern climes for the winter.

The decorative pond was oblong in shape,

Vines and roses on terrace wall. (Dorothy Norman, 1962)

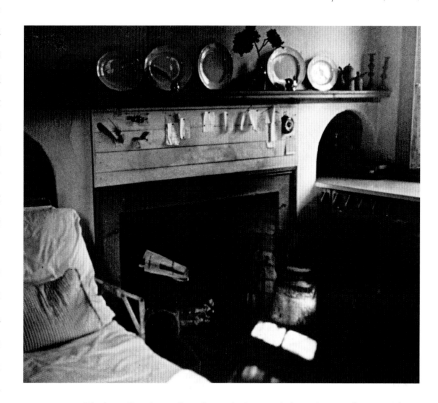

Kitchen fireplace, bamboo chaise on left and on right, a 19th C. Norwegian "Kubbestol"—a chair made from a tree trunk and traditionally painted. Built-in Scandinavian metal canisters below counter for flour, sugar, etc. Pewter plates line mantel. Behind chair is cubby-hole for dogs. (Photo by Dorothy Norman, 1962)

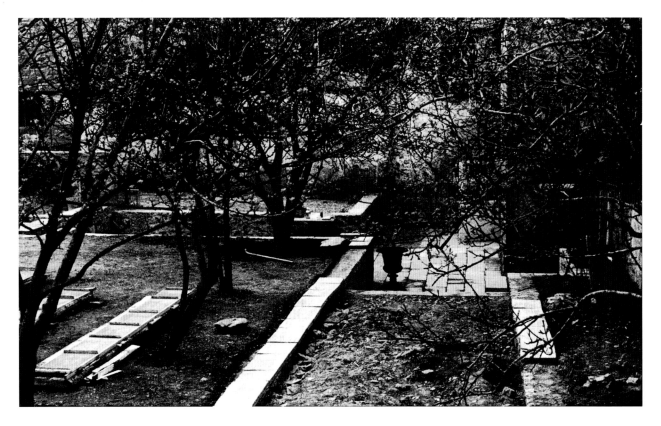

First-level garden during construction. Capstones being made on lower left. (Richard Svare, 1958–59)

six feet wide and forty feet long, and was bordered by cement paving stones, formed on-site via a technique Graves had used at Careläden and would later use at The Lake. A precisely mown lawn beside the pond was intersected by a paved path and ended at gated steps that ascended to a mid-level garden. A high wall of field stones rose from the pond, surmounted by a grooved channel from which overflowing water trickled down the wall and discreetly splashed into the pond below.

Directly behind the pond's wall, Graves designed and planted a traditional herb garden enclosed by a low English box hedge. Later, on a visit to Versailles, Graves would gather chestnuts and return to Woodtown Manor, planting a row of the nuts behind the wall of the pond. After leaving Ireland, he never again returned to see that the chestnut trees had grown to some sixty feet in the succeeding decades.

A cut-stone terrace led from the kitchen door, and its ample space provided for a slate-block table resting on two iron braces. Bamboo chairs were brought out when the weather was suitable. A four-foot retaining wall of field stone bordered the terrace, meeting, at a right angle, the wall of the studio. A small greenhouse was built and proved to be a boon, not only for raising delicate plants but as a place to sit in the temperamental winter sun.

Three distinct levels of garden ultimately comprised the final shape: the first level featured the long pond, the second contained the lawn garden and herbaceous border, and the third remained a wild space with natural pond. Outside the walls, elm and maple trees afforded further privacy. One bonus of the three garden levels of walls was the creation of ideal conditions for trapping sunlight when it broke through the clouds.

One of the rare, fondly welcomed visitors to Woodtown Manor was an Irishman known as The Pope O'Mahoney, an appellation given to him when, as a youngster, he declared that he would one day be Pope. He was small and rotund, white haired and full bearded, and was a raconteur extraordinaire with a phenom-

enal knowledge of the history of his country. One day, Eoin (his first name) wandered into Graves's garden and, wanting to be of help, began plucking weeds of which Graves was particularly fond and would sometimes "preserve" on his canvases. Graves reacted severely to his friend by declaring, "I'm the gardener here, Eoin!"

O'Mahoney enjoyed sharing his vast familiarity with Irish history and particularly the families who influenced its egregious annals, be they the disparaged Anglo-Irish gentry or, more to the point, the old, aristocratic native Irish clans. During one of O'Mahoney's two-day sojourns to the Manor, Graves asked his visitor if he would research the Graves family history. O'Mahoney replied that he would. Graves joked with me that just maybe there would be a grand house somewhere in Ireland that he could claim. The Pope O'Mahoney dutifully reported back to Graves: "I have looked into the matter but, unfortunately, the last of the Graves line died in bed at his home, which was a chicken coop!" Graves relished the irony.

A few close friends were able to share Graves's passion for gardening. Krissy Shackleton, a Quaker and a member of the respected Shackleton clan that had produced her cousin, Ernest, the Antarctic hero, was an inveterate and committed gardener. Graves enjoyed many an enlightened conversation with her, captivated by her wit and humor.

Peter and Gwen Harold-Barry were our oldest friends in Ireland, Graves having met them during our first year of living in west County Cork. The Harold-Barrys lived opposite the house we had rented on the tidal river, Ihlen, a sullen and somber passage that emptied into the Atlantic Ocean some miles westward. The Harold-Barry estate consisted of a severely plain Georgian house set in an idyllic garden. They were fervent gardeners and helped Graves make decisions at Woodtown Manor, advising him on which plants would thrive.

They tragically lost their adored daughter in an automobile accident and asked Graves to design a memorial

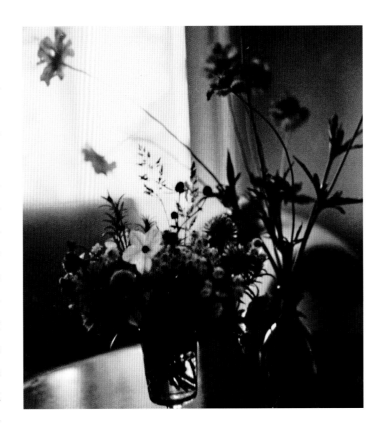

Interior still-life flower arrangement, dining room. (Dorothy Norman, 1962)

Morris Graves at garden niche with Irish Lion. He wears his usual winter outfit. (Richard Svare, 1958–59)

Pony trap left in the Long Barn—the only remnant of a former time at Woodtown Manor. (Richard Svare, 1959)

to their child. The stone, placed near the river's edge, survives still, with the beginnings of blooming yellow lichen decorating its surface. It is a simple, engraved chalice, poised and tipped in mid-air with its contents emptying, not as a chalice normally would but pouring forth its burden from its upper lip, on its opposite side. It is a metaphor that says much about Graves.

Situated in a secluded easterly area of the property is an abandoned quarry from which stone for the house was culled in the 18th century. The quarry had been in use, in an offhanded manner, through subsequent decades. When Graves assumed ownership of the Manor property, the quarry was completely idle. It did, however, become the Manor's swimming hole. Rainwater and seepage had filled the small crater of whitish stone, which lent a curious glacial-blue tinge to the water. Graves referred to it as a tam. We swam in it only twice, when a rare hot summer struck Ireland.

The studio and garage space, formerly a storehouse for the farm, was attached to the main house. The garage area had originally held the carriages, and its heavy double doors were suited for holding a car. Inside, the heating plant was installed in its own enclosed room and from it, a door led into the studio proper. The existing windows were small and placed high on the stone walls, so Graves had skylights installed on the northern exposure of the studio. The entire space was lined in fir, with open shelving along one wall. For its thick walls, it proved a delightfully quiet place for him to work.

The melancholy Long Barn, with its silent bell tower, was used solely for storage of gardening equipment and odds and ends. Care was taken of its slate roof and the cobbled lane that ran along its eastern wall. Graves regarded the Long Barn as a further sound and people barrier on the Manor's western border.

The next step toward occupying Woodtown Manor was to lay the beige wall-to-wall carpeting and its undermatting throughout the house on both floors, which added warmth

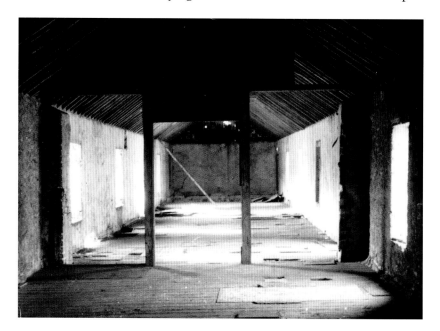

Second floor at beginning of construction. (Richard Svare, 1958–59)

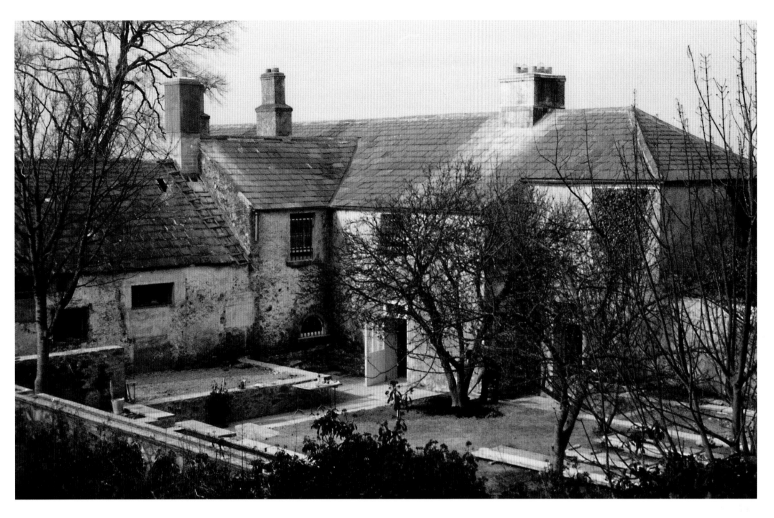

View of back of house. On lower left, water channel on top of wall from which water dripped into pond. (Richard Svare, 1958–59)

to the rooms and muffled an assortment of noises within the house. The slate-covered rear downstairs hallway remained, and the kitchen, pantry, and washroom-toilet were covered in commercial heavy-duty linoleum.

In late April 1959, the house was ready. We had accumulated various splendid pieces of Irish furniture, much of it 18th-century Georgian, and these were stored in the Fitzwilliam Square apartment, waiting to be taken to the finished house. Earlier, in 1957, we had acquired the pivotal pieces for the long drawing room: a pair of sofas originally made for the great house of Russborough in County Wicklow and covered in their original plum-colored cut velvet. Two large chaises were added, as well as a series of chairs in the Hogarth style, all from the same collection. To protect the fragile velvet, beige linen slipcovers were made and became the signature for much of the furniture at Woodtown Manor. The one exception was a white-painted Sheraton sofa and its cotton cover of blue and white checks.

These great pieces were included by Graves in the sale of Woodtown Manor and are now in the Victorian "Gothic folly" on Lake Luggala, as the former 18th-century hunting lodge is popularly known. Here and there on the whitened walls of the Manor were distinctly Gravesian touches. In the drawing room, on either side of the curving, bow window walls, Graves painted in subtle shades of gray, blue, and green two large oval shapes, roughly twenty-four by thirty inches, which resemble an astronaut's view of our planet. Other new paintings were propped up against chairs or hung as a lunette above doors.

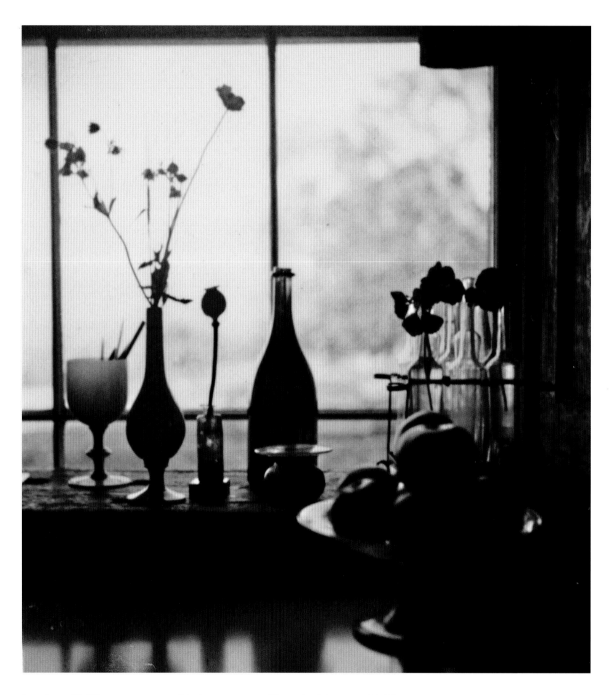

Interior still-life arrangement, kitchen counter. (Dorothy Norman, 1962)

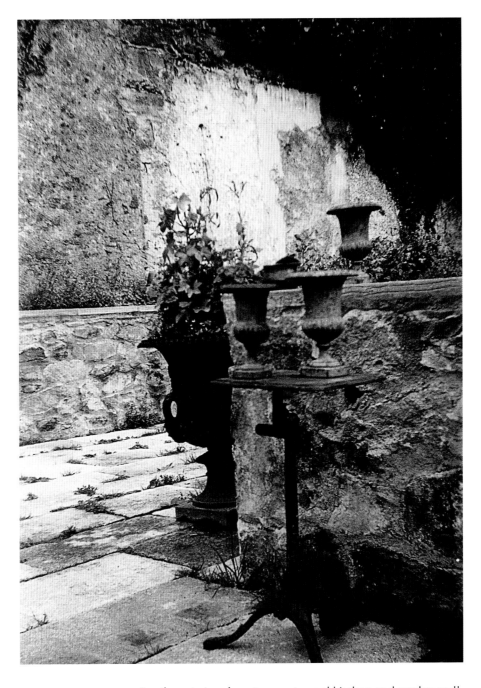

Southwest view from terrace toward kitchen and garden wall.
(Richard Svare, 1958–59)

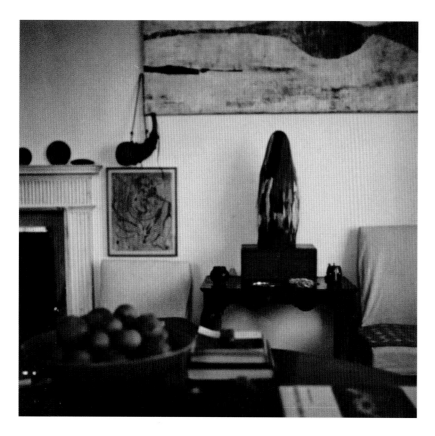

Drawing room, painting, right of mantel, by Mischa Dolnikoff. On table, a silk thread sculpture by Thomas Stearns. (Dorothy Norman, 1962)

Bay window end of drawing room with summer placement of furniture, two circular paintings by Morris Graves.
(Dorothy Norman, 1962)

Eclectic objects sat on tables throughout the house: an ancient fragment of carved marble; small Chinese bronze mirrors; and a dried flying insect, its gossamer wings moving almost imperceptibly from the slight movement of air in the room. Books were stacked on a table, beside a collection of nine small bottles in their own carrier or beside Greek rose water containers, opaque and holding a single flower. An African spear leaned against a wall, and a miniature bronze Buddha and a Kwan-yin proffered benign ambience with their customary patience.

For the warmer summer weeks, the furniture arrangement changed only in the drawing room. The Russborough sofas were moved away from the hearth and the low-backed sofa was pushed up against a bow window, the room at once taking on a buoyancy and lightness. The tall windows could be opened and the curtains pushed aside for uninterrupted views of the full-leafed trees beyond, from where Graves enjoyed the uncommon days of an Irish Indian summer.

One of the most attractive features of the house was the two-story bow window at the northern end. The graceful window punctuates the long room and looks out over the Vale of Dublin. There, Graves kept an antique telescope on a round three-legged table. On the second story, in the large guestroom, the space became a washroom and toilet, and contained a closet.

In keeping with the simplicity of the architecture of the house and its gardens, the rooms at Woodtown Manor were kept sparse. At the opposite end of the bow window of the double drawing room, a huge 17th-century Italian landscape dominated that part of the room. A refined but simple sofa sat underneath the dark,

Morris Graves at front entrance to Woodtown Manor during early reconstruction. (Richard Svare, 1958–59)

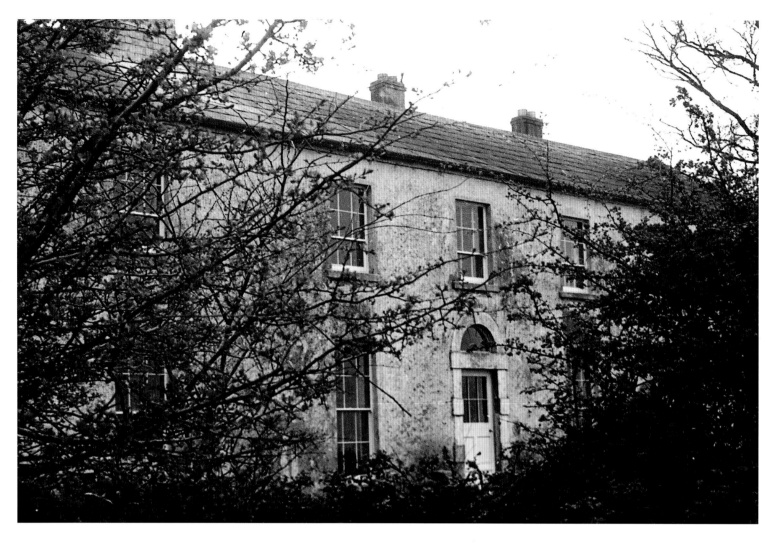

Early spring, Woodtown Manor with new windows, roof, and chimneys. (Richard Svare, 1958–59)

romantic painting. Hogarth chairs stood like sentinels against the walls.

Opposite the unadorned marble mantle and hearth were the two Russborough sofas and against the windows were the two chaises and additional Hogarth chairs. The three tall windows were curtained in the same linen as the slipcovers and designed with a three-sided border of darker linen. In winter, the interior shutters were unfolded to hold in the heat.

The entry hall was furnished with a long, bleached mahogany sideboard and mirror. An antique lantern hung from the ceiling.

The same sparseness existed in the dining room, with a gated table that sat eight comfortably in crossback chairs. Over a plain fireplace hung an 18th-century Japanese screen of grasses. To the left of the fireplace was an original built-in cupboard. A double-curved Irish sideboard stood opposite against the wall.

Of all the rooms at Woodtown Manor, the kitchen most exemplified its farmhouse character. A large, open fireplace shared the chimney structure of the dining room. On either side of the hearth were two curved openings, one holding bricks of peat. In the center of the kitchen stood a long pine table with pine chairs on two sides. A pull-down light fixture hung directly over the table. The open-shelved cupboards and windows were

hung with gray and white ticking. On the counters sat baskets of fruit or vegetables and baize-lined baskets of silverware. A Scandinavian convenience held built-in windowed canisters of flour, sugar, cereal, and other items. The door, which opened on the kitchen terrace, was a copy of the front door, without the fan light. The door was split so the lower half could be closed and the upper half opened. A similar door led into a roomy pantry and separate toilet and washbasin. The Manor's back door, used for deliveries, replicated the inner door, and at this back door, Graves designed a small bridge that crossed a streamlet. The streamlet ran along the southern side of the house and then disappeared underground. The base of the course under the bridge was cemented and indented with bowl shapes of varying sizes, which produced a series of melodic gurgling sounds.

On the second floor, a minimum of furniture contributed to the sparse, farm-like character of the house. Two guest rooms, one large and one small, were furnished with visitors roundly in mind.

Graves's favorite place to be a guest was at the Long Island home of his longtime friend, the writer Nancy Wilson Ross, whose guest room—set apart from the noises of the house—contained everything a guest might need: a cozy bed, books and a good light for reading, a comfortable chaise, bowls of potpourri, jars of sweets, and a handy box of chocolates!

In memory of those halcyon visits, the guest rooms at the Manor featured comfy beds to luxuriate in and complete privacy. A third bedroom, with a small fireplace, led into a large dressing room with one wall devoted to built-in cupboards. The dressing room, in turn, led to the master bath. An enclosed tub with mirrored wall and separate shower stall comprised one side of the room. At a right angle were the toilet, built-in washbasin, cupboards and drawers, and a mirrored wall. Built-in cupboards filled the southern wall and a hot-water towel rail was installed in front of the radiator and window.

Graves's bedroom was monastic in comparison to the creature comforts of his bathroom: a single bed with a cover of linen

View of kitchen door to terrace.
(Dorothy Norman, 1962)

Rare photo of Morris Graves at work in countryside.
(Richard Svare, ca. 1950s)

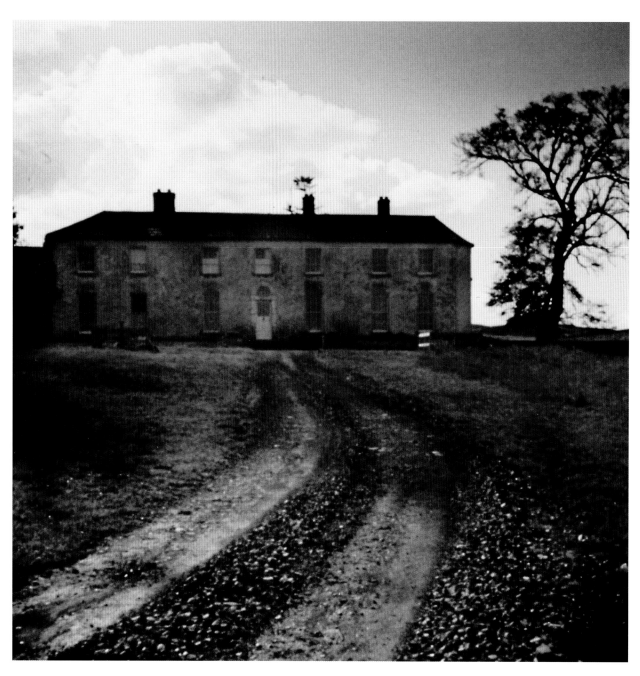

Bow window façade, facing north, slate-shingled wall. (Dorothy Norman, 1962)

Kitchen terrace, Richard Svare and Polly preparing snack. (Photographer unknown, 1958)

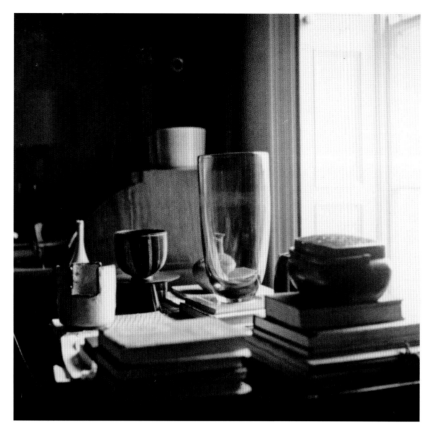

Interior still life, drawing room. (Dorothy Norman, 1962)

and its bedside table and lamp, two Hogarth chairs, and a plain fireplace and hearth. At first glance, there appeared to be a walk-in closet but in reality, it was a small, empty room with one window and one chair. In that cell, Graves mediated. He jokingly referred to it as his coffin. At this writing, it still exits.

The graveled avenue, gravel court, and low walls in front of the house were Graves's final Woodtown projects. The former avenue into the property was an unappealing drive past slowly encroaching suburbia. Graves designed a new entrance to the Manor from the upper secondary road, which eventually led past the Hellfire Club and to the treasured Sally Gap beyond. Two large, square gate piers gave no indication of the beauty that awaited a guest. Anchored between the gate piers is still a cattle grid, and a plain, black iron gate swings open downhill. The avenue meanders into a graceful curve through the fields of yellow gorse, enters a copse of deciduous trees, and ends at the severe, not-too-welcoming gravel court in front of the house. A smaller graveled lane veers to the right of the house, toward the garage and outbuildings.

The last hurrah of creativity in Graves's studio at Woodtown Manor took an astonishing direction after his unexpected and profound meeting with Werner von Braun of NASA. The conversations took Graves entirely by surprise but confirmed his long-suppressed and subliminal fascination with the reality of outer space. The realization affirmed his Vedantic view of one's passage here on earth and among the stars.

The result was a series of constructions that Graves called "Instruments for New Navigation," which were made of various materials, from metals to semi-precious substances and objects. Graves contracted with a Dublin firm to assist in assembling the "Instruments," but the experience of their mishandling and the egregious mistakes committed by the workshop were more than Graves could tolerate. As each piece was completed, he nevertheless placed it on a table near the bow window, which allowed the soft Irish light to pierce the glass or mica or alabaster of the instrument. They were poised as silent sentries in that long, handsome room, and their cryptic, mysterious presence became an indelible fixture until Graves, despairing of what he considered their fallibility, packed them up to be seen, perhaps, another day.

With peat fires lit in the hearths and the primordial earthy aroma drifting through the rooms; with the ongoing tending of his gardens, the water trickling down into the pond, and the sight of a minnow darting through the water weeds; with the warmth and light of his studio and the quiet privacy of Woodtown, Graves began to relax as best he could. A period of intense painting followed, and also periods of travel, homecom-

ings to Woodtown and more travel, all preceding the precipitous moment when he decided to leave the Manor behind and return to the United States.

<p style="text-align:center">Postscript</p>

In the ensuing years, the once trim and loved house, the revitalized and comely gardens, and the surrounding fields of comforting flocks of sheep have vanished. Because of apathy and woeful inattention, the now muddy gardens and fields again have gone to seed but astonishingly, hints of Woodtown Manor's former splendid self still exist and they alone redeem it from oblivion.

Woodtown Manor has recently been sold to a developer and the Dublin rumor-mill has it that those serene fields that enclose the house and garden will be obliterated by a colony of town houses.

Sic eunt fata hominum: "Thus go the destinies of men"—and their houses, one must perforce add.

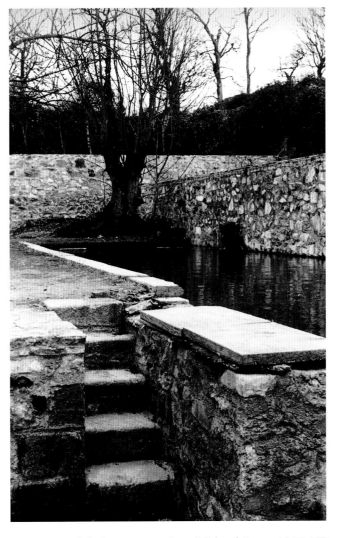

Pond during construction. (Richard Svare, 1958–59)

More than once I fed this bird of flight,
this lover of light, to capture
that fluid of song
in this blue jar I keep under the stairs
beneath the stars.

from Galen Garwood's *Adagio*

Interior still life, drawing room, Woodtown Manor. (Dorothy Norman, 1962)

*"If there is a Paradise on this earth,
It is this, Oh, it is this,
Oh it is this!"*

THE LAKE 1965—present

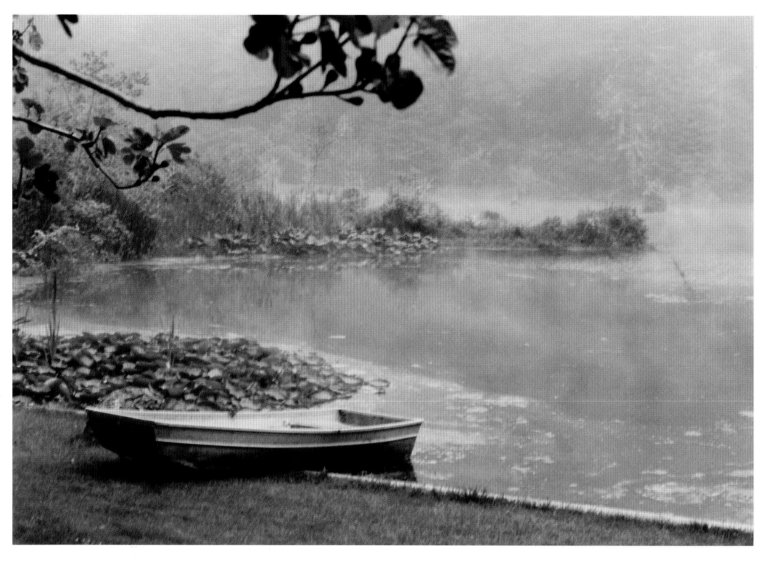

Lake shore on a misty day. (Robert Yarber, ca. 1990s)

previous spread: View from the Long Room at The Lake. (Ray Kass, ca. 1990s)

The preceding quotation, found incised on a fragment in a ruined palace in Old Delhi, amiably and accurately reflects Morris Graves's joy and delight in creating his final house and garden. His long-held wish was to combine architecture and the presence of water.

During the Irish years, he looked in vain for a moated house. One was finally discovered, only to be sadly rejected because the winding avenue and surrounding gardens had once been shaded by ancient copper beech trees, which had been butchered down to unsightly, even ugly stumps (the owners were financially strapped and in need of cash, a not uncommon occurrence suffered by the venerable, great houses in Ireland).

The decade of living in Ireland had its great measure of geniality, overlain with that lively agitation peculiar to the Irish. Nonetheless, Ireland had filled Graves with deep inspiration: he delighted in the poetic nuances of speech, the near-mystic interpretations of Ireland's natural and mythological world, and his explorations of the abandoned estates of the Anglo-Irish glory days. He became fascinated by the precise Georgian houses still intact and alive.

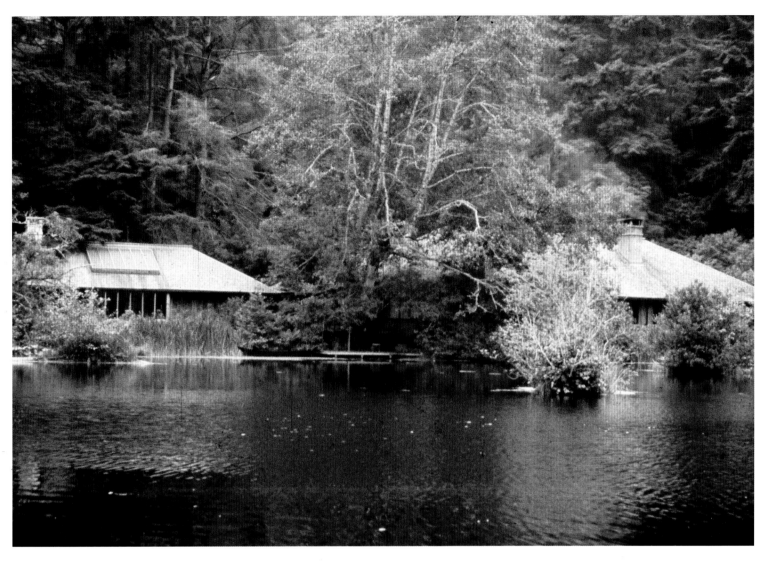

Main house and studio. (Ray Kass, 1980)

All that was not enough to keep him residing in the Irish countryside, and his decision to leave grew from a single kernel of thought. He kept his thinking to himself at the time, revealing not a glimmer of the decision to come. True to his essential disposition, he would, when the moment arrived, be able to walk away from Woodtown Manor with the same expediency and dispatch as he had from The Rock and Careläden.

On a visit to the United States in 1957, Graves and I drove southward along the magnificent Oregon coast and farther south, marveling at the ancient, towering stands of redwood trees where shafts of sunlight barely penetrated to the lush forest floor. The drive ended at the northern California town of Eureka and from there, Graves made forays into the surrounding countryside. He noted that the climate in many ways resembled that of southern Ireland—for him, a good omen.

There was no mistaking that Graves was much taken with the environs of Eureka. The bare hills, with drifts of oak trees, fall gently toward the omnipresent Pacific Ocean. Skeins of ocean mist hang and silently float among the taller trees, obscuring their tips. It is a world Graves could inhabit, living far enough away from town,

which in itself was no burgeoning metropolis, to sustain his beloved privacy.

Graves decided to make discreet inquiries at a local real estate agency. A particular property was mentioned, in effect two hundred acres of forest situated on a high rise of land and containing a small lake. It would prove to be Graves's *coup du ciel*—a providential stroke of good fortune—and it would be called, simply, The Lake.

Endless negotiations ensued, far surpassing those that preceded the purchase of Woodtown Manor. Days and nights were charged with difficult, often combative conversations; wily maneuverings; and reminiscent of Ireland and through it all, Graves's increasingly steely determination to own the property. After months of arbitration, peacemaking intercessions, and excruciating delays, Graves allowed himself the luxury of understanding that The Lake was his and he could begin the exhilarating prospect of making what was to be his final home and garden.

In an exuberant letter dated April 21, 1965 and addressed to his friend, Jan Thompson, Graves wrote: "...you wish me happiness, Honey—what I have is absolute ecstasy! I've never known anything like it. I can't begin to tell you my state-of-mind except to say that there is nothing on the lake but drifting mist and us herons! Honestly the delights are absolutely countless. Among them my favorite sound in all of nature! That bleak blurred dissonant call of the veried [sic] thrush. Nothing defines and heightens forest solitude more than the call of this thrush—nothing more eternal autumn in mood. There are absolutely unending beauties I

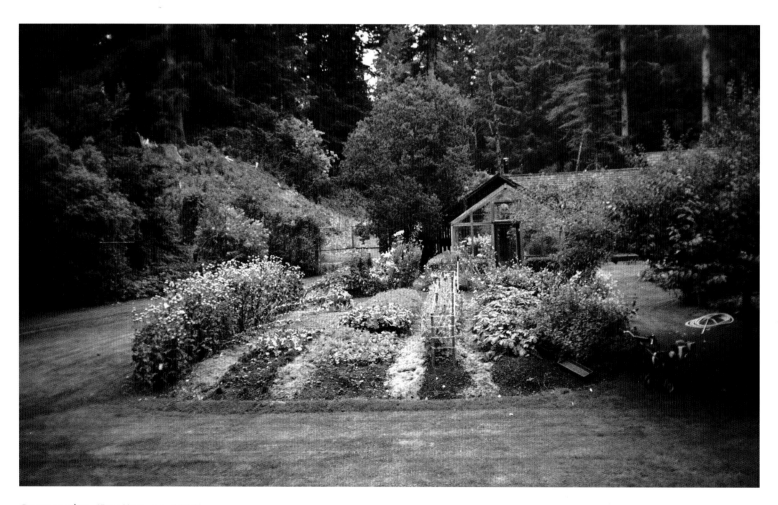

Outer garden. (Ray Kass, ca. 1980)

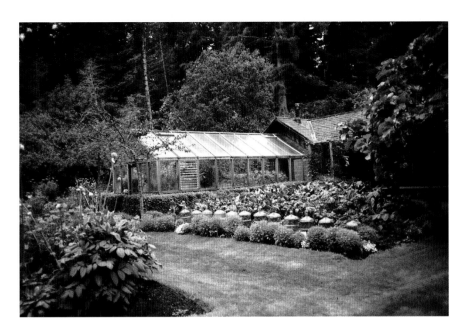

View toward inner and outer garden area, off kitchen. (Ray Kass, ca. 1980)

keep discovering on the property."

In the same letter, Graves discloses an uncharacteristic method for making a garden when he says, "I have two good husky men doing the hard work for two weeks, getting ready for the bulldozer! Can you imagine me 'landscaping' with a bulldozer and two men with chainsaws?"

Graves was confronted with the enormity of creating a garden out of a dense forest and its entangled underbrush. He had carved out a garden from the woodland at Careläden, and to some extent at The Rock and at Woodtown Manor, the latter more a matter of clearing away generations of debris. The Lake would involve a massive effort, taking both manpower and machine to gentrify the primeval thickets. With his customary obstinacy and single-minded tenacity, Graves set about the scheme for his garden, a project that would consume his energies for years to come, both physically and emotionally.

The taming of the access road that eventually was to end at The Lake was, for many reasons, a colossal project. The track literally accommodated only one car or truck at a time. Later, a space for pulling over was carved out at a tight curve that looked over a steep ravine, which made for a hazardous drive up the road. At a halfway point, the road became two-rutted, typical of a former logging route. This proved to be the most critical section to civilize, but it was accomplished with care and generous S-curves that wound through sunlit fields.

Without warning, the road slips into lush groves of trees and bushes, and beneath a lofty canopy of redwoods, where the first-time visitor recognizes that he has reached an altogether different sphere.

To any visitor, it might have appeared a perverse act on Graves's part to make his home in such an inaccessible location. In that manner, The Lake hearkened back to his first house and garden on the pinnacle of the rocky outpost in his home state of Washington. It was, in true Gravesian tradition, an appropriate simile for his final effort to combat the blatant cacophony of the 20th century, in an America that he felt

Morris Graves and Robert Yarber, (Photographer unknown, ca.1980s)

79

had betrayed nature.

The lane of closely clipped and dense natural hedges comes to an abrupt end in an open space with a concise, clearly painted sign—"Park Here." It is then only a few steps to a solid wooden wall, a stone walkway along the wall, and an unassuming pair of double doors and, in Graves's day, a doormat that curtly declaimed, "Go Away." A handwritten note, pinned to the door, declared, "No Visitors Today." For the faint-hearted, these Spartan messages were as threatening as an angry mastiff and proved effective in keeping the public at bay and preserving Graves's immutable predilection for privacy.

Early on, he sought out the Seattle architect, Ibsen Nelsen, having responded to a building of Nelsen's in Seattle. The two men had lengthy discussions about Graves's ideas for his lake house, and without undue delay the work began and progressed to his satisfaction. The unprecedented efficiency of effort and time persisted,

Main house, front entrance with wooden shoes. (John Woodbridge, 1984)

The Lake's garden islands, formed on remnants of ancient redwood stumps logged 100 years ago. (Robert Yarber, ca.1990)

until the seemingly predestined moment when Graves clashed with his architect. Despite this substantial bump in the road, the house was duly completed, and it is to Nelsen's credit that he survived the difficulties in interpreting Graves's wishes to such sensitive and elegant effect.

Any memory of the natural and induced barriers nurtured by Graves quickly fade once one climbs the few steps to the front doorway and passes into rooms that, not surprisingly, are reminiscent of The Rock and Careläden. The soft glow of the paneled walls, unprimed by any source this time, are a mellow background for kakemonos, screens, the occasional sculpture, and other objects. The hallway runs the length of the house, with a jog in its route to the bedrooms and bath.

Two pairs of double doors step down to the Long Room, which we called the living room, a space of great serenity as it looks out directly on the wonder of the mere from which Graves took the name of his forested retreat—The Lake.

It is a body of water that encompassed all of Graves's memories of his childhood in the Pacific Northwest, when he roamed the pristine woods near his parents' home, exploring the mountain tarns that dot the alpine valleys of the Cascade Range and quietly observed the timorous water birds on the fragile wetlands so valued

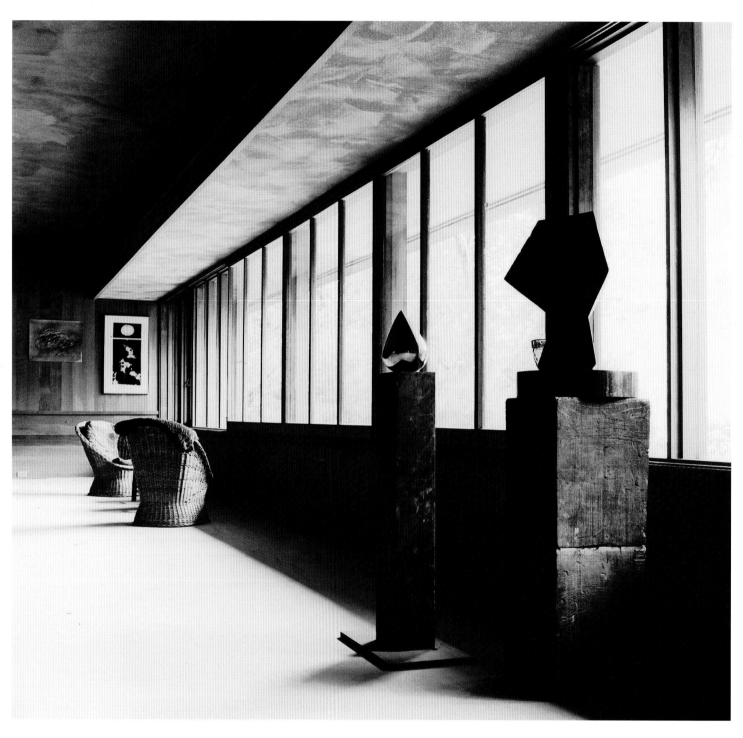

The Long Room at The Lake. (Mary Randlett, 1967)

The Lake. (Ray Kass, ca.1990s)

Lakeside façade of main house. (John Woodbridge, 1984)

by the Native American tribes. The journeys to Japan in his adult years indelibly formed his impressions of the simple beauty of water, and viewing the grand expanses of land and water composed by the painter and architect Inigo Jones in 17th-century England gave impetus to his dream of The Lake.

The surface of the lake, from which emanates a lovely pewter light, is sprouted here and there with vestiges of ancient redwoods, whose roots lie deep in their watery garden. Graves planted the stumps with grasses, and their plumes, together with flowers that have seeded themselves, are reflected precisely in the dark water. The entire scene has a topsy-turvy aspect that deceives the eye, adding an already surreal perspective to the ocean mists that soundlessly envelop the lake.

In an inlet, lily pads thrive and are suitable cover for fish hiding from the resident grey heron, which can be espied perched on one of the grassy outcroppings, standing utterly still and waiting to pierce the water with its beak. Wild ducks and thrush haunt the opposite end of the lake, secure in not being disturbed. Swallows dip and soar and a lone osprey glides to its nest in a tree at shoreline.

As Graves himself penned in a note, pinned to a studio wall: "Silvery minnow-moment, flash-gleaming in the depths, now seen, now gone...."

Weather watching on the lake, for Graves, was a consummate pastime. He delighted in the gusts of wind that send ripples scurrying across the surface of the lake, or an early evening shower of raindrops pelting the mirrored water, distorting the reflections of clouds, trees, and spikes of cattails along the shore. The divergent weather on the lake would be entirely smothered when a cloak of misting fog reached inland, and the lake itself would simply disappear—a variance of nature that thrilled Graves. This sleight of nature's hand coincided with his own variable temperament, which often would confound close friends and strangers alike.

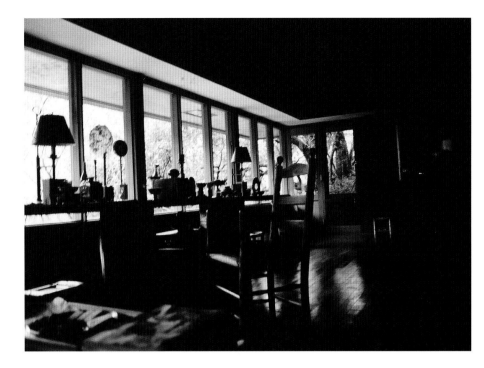

Sitting room, kitchen wing. (John Woodbridge, 1984)

In the Long Room, Graves was wont to set one of his Hogarth armchairs near the open fire, with a standing lamp for reading and an ashtray, and consider what he had wrought in taming his forest demesne.

The room recollected earlier interiors at Careläden and Woodtown Manor, reflecting their tranquil sobriety. Understatement was characteristic of Graves and here, at The Lake, he once again established that curious mixture of sophistication and ingenuousness, which was never more evident than in his lakeside living room. The sofas, one an Irish reproduction and the other modern, were covered, as at Careläden, in dark blue velvet. Judiciously placed were his "signature" ample and square foot stools and the Hogarth side and armchairs. The room echoed our decision at Woodtown Manor to create the Russborough "suite," with the Hogarth chairs and dining chairs covered in identical plain-linen slipcovers. The element of sameness or consistency was the calming component in all his rooms, in all his houses, and was inspired by a photograph of the Russian interiors of the estate of Count Leo Tolstoi.

A weighty collection of handsome and seasoned 18th-century Irish tables and a pair of antique Japanese chests were placed about the room, some side by side, their surfaces crowded with myriad found objects and gifts from well-intentioned enthusiasts: rock crystal forms, prehistoric rocks, a feather, a bowl of rare beads, and the dried skeleton of a lizard. Graves often lamented the fact that he wanted to divest himself of possessions, yet he was, in his dazzling prime, an inveterate collector, relishing the odd, the impulsive, often the madcap object, but always with a coolness, anticipating how it might affect his next work. An anteroom, once his studio, is still shaded by bamboo blinds and retains a hushed atmosphere; like the living room, it is windowed wall to wall and looks out to the lake. With its customary paneled walls, the room sustains memory, perhaps more than any other in the house. Bygone energy, suffused with the anxieties of creating The Lake and painting, permeates the room in its present uselessness. An outside door opens on a path that leads to the present studio, aban-

Low-slung roof lines of main house. (John Woodbridge, 1984)

opposite: The Lake. (Ray Kass, ca. 1990s)

Main house and studio. (John Woodbridge, 1984)

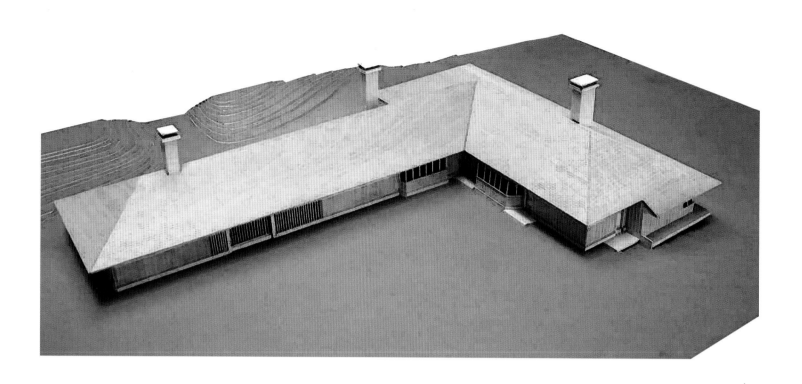

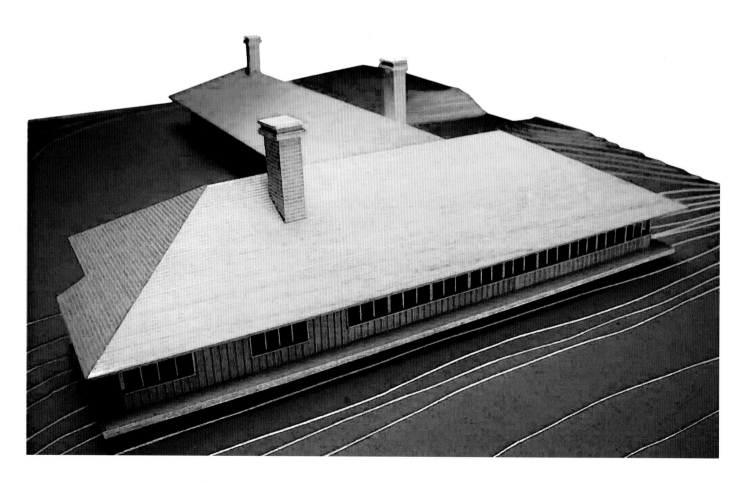

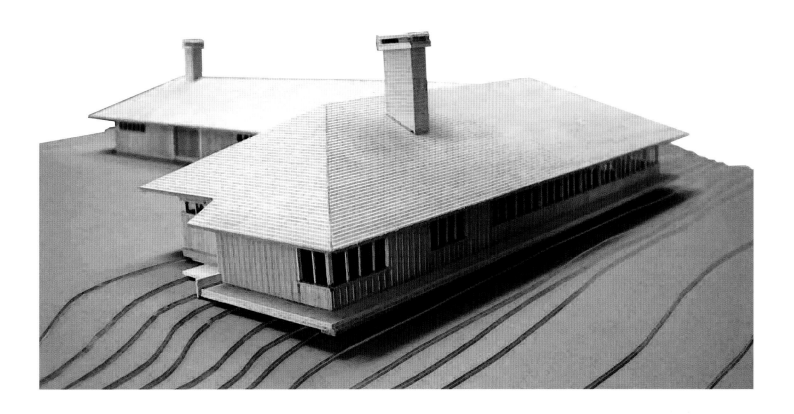

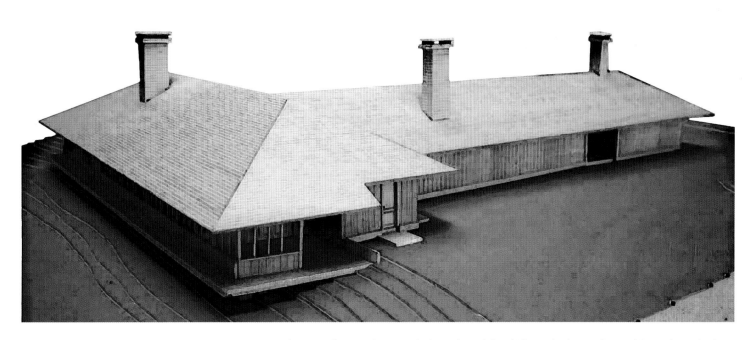

above and opposite: Rendering of models of The Lake house by architect Ibsen Nelson.

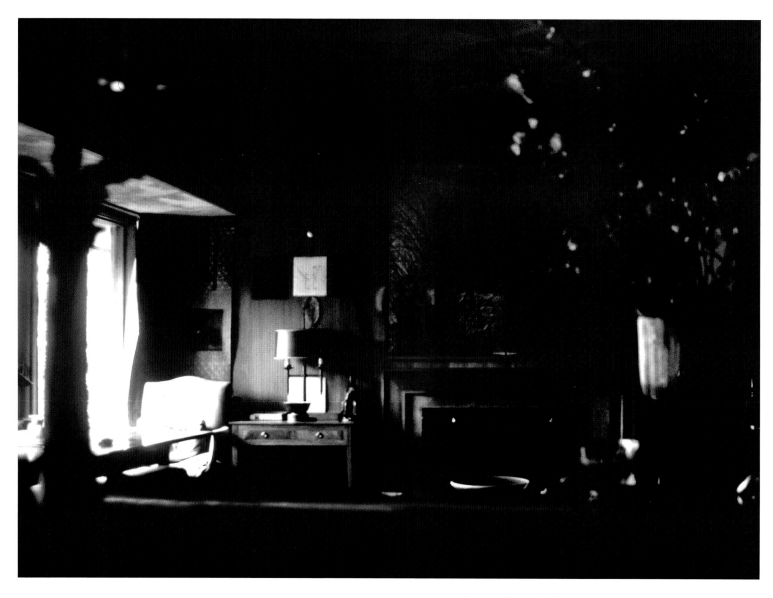

Fireplace wall, end of living room. (John Woodbridge, 1984)

doned since Graves's death. The walls are white, the windows look out to the lake, and the gigantic leaves of Devil's club below the studio brush up against the windows, scratching against the glass, the only sound remaining in the room.

Returning to the house, at midpoint, the hallway opens wide to a large raised platform and a padded banquette constructed in a generous bay window that overlooks the garden. A fireplace is opposite. Outside the windows, a vine traces the bay and shades the room.

From here, the hallway leads to Graves's bedroom. A short flight of steps leads down into the small, plain, sparse room with an Irish chest of drawers, a built-in closet, and in a niche a small wood-burning stove. A windowed door opens on the narrow deck that runs the length of the house and looks out across the lake and rushes of cattails. The bed, with its build-in headboard with reading lamp, casually disregards the view of the lake and faces the door to the room, for reasons known only to Graves. Perhaps the benevolent view of his lake, even at night, was conducive only to waking dreams.

Beyond is the large guest room, again with a brief flight of stairs, which houses two beds with an unobstructed view of the lake and the trees on the opposite shore forming the backdrop. An accommodating bath, opposite the bedrooms, has a wall of paneled cupboards, a discreet toilet, and a built-in washstand of an elongated oval basin made of metal and set high enough to accommodate Graves's tall frame (a bane to his rare visitors, most of average height). Long, narrow windows below the ceiling let light fall over the extra-long bathtub he could easily lie prone in, and there is a roomy, separated walk-in tiled shower stall.

The heart of the house is the spacious kitchen with fireplace and low chairs drawn up to it. On either side are cupboards that disappear into the paneled walls. Opposite are the work surfaces of countertop stove and a double sink. Deep-silled windows along a wall overlook the garden. As at Woodtown Manor, curtained open shelving runs conveniently under the long counter and at a right angle are the eye-level oven and closed cupboards; below them, utensils rest in the drawers. A shaded lamp hangs over the long wooden table in the center of the kitchen. Items we used at Woodtown Manor nostalgically sit on the table: round, woven table mats; a Waterford salt cellar; and silver napkin rings. A venerable wood-fired iron stove sits unused at one end of the table, a remnant of Graves's early days at The Lake.

It is a warmhearted room, in an emotional as well as a physical sense. Graves liked to sit by his fire on a low 19th-century Norwegian *kubbestol*—a chair carved out of one piece of wood, usually a tree trunk, and painted in the traditional style. It was given to him on a winter visit to Norway in 1957, following his time in Paris as a guest of the Duke and Duchess of Windsor. It was here in The Lake's kitchen that he spent much of his time, preparing and eating meals, reading at the table with his back to the fire's warmth, talking with friends about his never-flagging interest in the state of the world, and despairing of politics and politicians and the mind-boggling behavior of his fellow man toward nature. If the guest were a friend of long standing, they would share news and gossip of mutual acquaintances.

From the kitchen, a door with glass pane opens to the huge storage area. Ceiling-height stacks of chopped wood are meticulously piled and at the ready for building fires in stoves and fireplaces throughout the house, its only source of heat. A vertical lattice wall, providing movement of air for the chopped wood, faces the garden and opposite, the wall remains solid. One section is

The Lake. (Ray Kass, 1980)

91

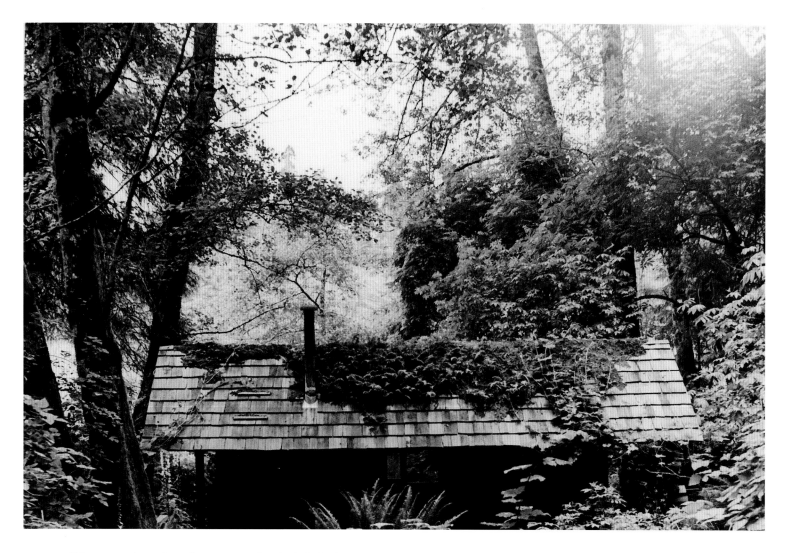

First small house at The Lake, where Graves lived while building the main house. (Ray Kass, ca.1980)
previous spread: The Lake. (Ray Kass, ca. 1980)

reserved for Graves's station wagon and at the end of the storage area is a spacious and furnished one-room living quarters for resident help.

Easy access to the garden is available from the kitchen, the middle room of the hallway, and the end of the bedroom hall. From each, a walk and terrace of cement slabs—poured on the site—lead out to the grass swards and the extensive clipped English box hedges that enclose the somewhat formal part of the garden. The hedge is approximately four feet high and surrounds the large inner garden of roughly one hundred by fifty feet. Ground covers of violets (*Viola labradorica, Ajugas reptans*, and sedums) have aggressively overspread the edges of the walk that extends from one end of the enclosed garden to the other. At the walk's terminal closest to the house, a gigantic plump stone urn and pedestal sit majestically, rising above the hedge. Midway through the garden, the ground level rises a step up and the walk ends at a small and restrained gazebo with a high-back wooden resting bench.

It is an intimate space Graves envisaged as a cutting garden for annuals and herbs for the kitchen. Its form and mood is that of a medieval pleasance, and the present relaxed state of the garden heightens its mature appearance

and lends grace to its ever-increasing patina. Perusing the garden, it is possible to be gripped by an overwhelming sense of having somehow returned to a time and place both familiar and otherworldly.

Outside the box hedgerows, a mown grassy expanse is sheltered by towering Chinese dogwoods and in their flowering, the luminosity emits a ghostly glow at dusk. When the flowers die, they tumble down onto a long, right-angled wooden bench, now completely shrouded by a cloak of moss that has disguised its original purpose. The canopy of trees, its own barrier to the outside world, stands oddly emblematic of Graves's passion for merging inner and outer worlds, and reminds the visitor of The Lake's raison d'être.

Screened discreetly by the dogwoods is an open-sided pavilion and from it, a grass path skirts the lakeside and ends at a startling skeleton of a hut that Graves built early on, where he first cleared saplings and underbrush for what was to become The Lake. The four supporting posts, the shingled roof, and the sloping cover for extra shelter and wood all remain. As the underbrush has since sprouted up and through the framing and the moss-laden branches of the trees drape the roof, the hut has become a silent reminder of Graves's persistence in realizing his worldly dream.

Farther on, a forest path encircles the lake. Along the edges of the path, age-old fallen trees have begun to disintegrate, their bark tenuously attached like flaking skin. The thick mass of towering trees barely admits the sun's rays, and on one's eyes the shadows play weird tricks. In the shaded light, some logs with rough, scaly bark appear as strange beasts—an alligator lying in wait, an elephant's poised leg or trunk, a spotted leopard ready to spring. But soon enough, the path leads to an open space with a direct view of the low-slung house and its wall of windows from across the water.

Two smaller houses, harmonious in their positioning, stand by the lake's edge on its opposite, western shore and a goodly distance from the main house. One was built as a retreat where Graves could catch the warmth of the afternoon sun on a cantilevered deck. The other, a snug abode, sheltered the caretaker of Graves and the property. Robert Yarber, together with two devoted helpers, took care of Graves for many years and particularly during the last weeks of the artist's life. Yarber related that in the moments following Graves's death, the resident great grey heron emitted his piercing, strangled cry, which echoed across the lake and through the giant trees—a fitting final farewell.

In essence, the lake is the garden. The grassplots, the arboretum, the flower plantings all seem extraneous next to the irresistible visual and emotional pull of the lake.

Whichever form The Lake takes in its new life, for the nobility of its inception and the assiduous care of those who would preserve its heart and its spirit, future visitors will be grateful.

Postscript

A palpable silence, more intense than during Graves's residency, has descended upon The Lake. His presence is as yet undiminished and pervades the garden and permeates the rooms he intimately inhabited. Here and there on the paneled walls are a few of Graves's early paintings, which brought him to the attention of

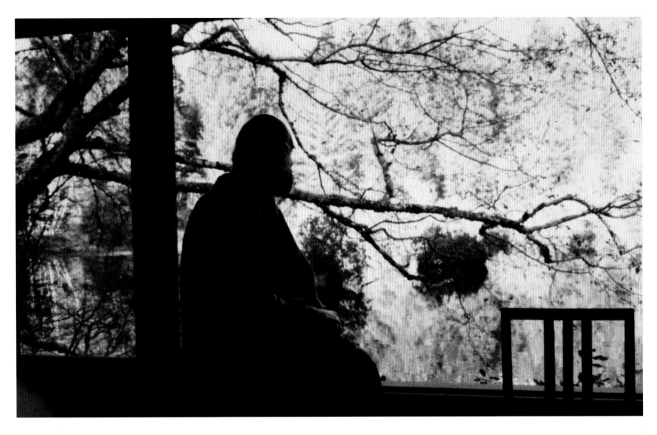

Late photograph of Morris Graves, (Photographer unknown, ca. 1990s)

various art communities. Also, an early 18th-century landscape in oil; a prophetic portrait of Graves, painted by his friend, Carlyle Brown, and hung discreetly behind a door; some anonymous paintings given to Graves but at odds with their environment, looking mildly ill-at-ease; amulets; totems; bronzes of China; Japanese ceramic bowls and vases; Irish silver candlesticks on Irish tables; a Tibetan tanka—all are first-hand witnesses to his peripatetic existence.

The gardens within the precinct of the house have become relaxed, reflecting his dwindling life. He understood that his legendary physical prowess and energy were waning and soon to be no more. He had done enough digging in the earth, enough planting of trees and nurturing of flowers, and now he could let go and allow nature, which he had challenged so consistently and at times so fiercely, to begin its irrevocable renewal. At last he could begin his final journey, the one that, in many ways, he had aspired to all along.

The reluctant spirit of Graves is omnipresent in the houses and gardens he made and especially at The Lake, with the intense flavor of its indefatigable and unremitting creator, whose presence is potent and irresistible. His unique aesthetic is visible everywhere the eye chances to fall. A glimpse can still be had, as if looking through his own keen, heron-focused eyes, of what he envisioned.

The Puget Sound region of Washington State, with its variable inlets reaching into soggy wetlands, is often the habitat of the Great Blue Heron. Its tenuous and spectral visage, seen and unseen in the tall grasses or poised unmoving in shallow water, is an appropriate symbol for Graves. The heron's angular stance and its aloof demeanor accurately depict Graves's complex character. There is no question that he felt a kinship with these redoubtable creatures, and his paintings of them evince this intimacy.

It was to be his destiny that the heron would figure so prominently within the ken of the houses and gardens Graves would establish: the herons of the aeried Rock and its protective shores far below; the lone, roving heron alighting in Careläden's pond; an Irish heron making its singleminded way soundlessly in the ponds at Woodtown Manor; and above all the heron he experienced within himself at The Lake. In all these places, the heron's artless presence was utterly apparent, as Graves's life ebbed away. In a letter to Jan Thompson dated December 21, 1955, Graves wrote, "If earthly departures so darken the eyes how will one ever bear parting finally for the Great Dark Journey???"

Afterword

Morris Graves's early quest was a wayfaring migration until he discovered the need to establish a home and a garden, which led to the creation of four uncommon retreats.

Throughout his long life, Graves's desire to make a place for himself on the earth was eclipsed only by the one vital element that eluded and haunted him—the enigma of silence. It was his greatest challenge, and he sought it not only in the four retreats and in his painting, but in the deepest night high up on The Rock, behind the intimidating walls enclosing Careläden, in the cell-like room within his bedroom at Woodtown Manor, and via the impenetrable barrier of the stupendous redwoods at The Lake. Even the journeys to remote destinations failed to satisfy his hunger for a silent space.

With prescience, Graves always understood this quest would be realized only in death. But until that final moment, he would relentlessly follow his rangy shadow in pursuit of the enigmatic and the inevitable.

"Man is but a breath and a shadow," says Sophocles in *Ajax the Locrian*.

Graves reveled in that brief passage to which humankind, flora, and fauna are subject. His own extended old age belied that ancient dictum, however, and he profoundly regretted living so many years beyond when he felt ready to participate in the great transformation from body to spirit. It was a longstanding regret, subtly detectable in letters, conversations, and even in certain items found in that most personal of environments, his bedroom. A book of poetry on his bedside table is opened to a darkly lyrical poem by Louise Bogan, or a slip of paper pinned to the wall bears an agonized phrase, which would perhaps see the light of day as a title for a painting, succinctly echoing Graves's longing for release.

Graves often spoke of the Hindu concept of the *lila* (pronounced lee-law), God's playful regard of the world, which manipulated man's existence. Graves would interpret this, when speaking of his eventual demise, not as an occasion for the shedding of tears but for irrepressible laughter. In the incipient and impermeable seconds of his dying, perhaps Graves somehow foresaw a light-hearted entry into the realm of peace and at last knew he could rest easy.

Regardless, it is fitting that Graves himself has the last word. In the only public speech he ever gave, at a remarkable conference in India in the spring of 1987, he ended his comments by reminding us that all of humanity shares at least two languages—silence and laughter.

Red Raft on Yellow River

When you give to gravity
what you took from time and mistook
for reason, when your dreams are, at last, let
loose and topple back empty
upon emptiness, when the mist
of memory's flight descends to close out the light
the lids struggled to shutter for so few years, will you then want
one last look before the chemistry of your vision is leached
back into the earth
and held fluid and still?
Will you?

from Galen Garwood's *Adagio*

Morris Graves, (Photographer unknown, ca.1990s)

Acknowledgments

The Project Team is grateful to the Museum of Northwest Art for their encouragement and
to the following who have generously contributed to the production of
MORRIS GRAVES ~ His Houses, His Gardens

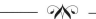

Benefactors

Paul and Debbi Brainerd
Patricia and Dale Keller
Pacific Lutheran University
Raymond and Estelle Joan Scheetz
David and Catherine Eaton Skinner

Patrons

Vasiliki Dwyer
Donald L Currie and Daniel Gladstone
Gary and Vicki Glant
Jeannie and Charles Gravenkemper
Randy and Jan HolbrooK
Joey Kirkpatrick and Flora Mace
Naomi Lindstrom
Carol Mousel
Walker Novak and Jim Jackson
Solveig and Jeff Peck
Lucy and Herb Pruzan
Dick and Lvonne Reim
Maggie Walker
Charles Price and Glenn Withey

Sponsors

Jeffrey and Brenda Atkin
Chris and Cynthia Bayley
Pricilla Beard
Gudrun Brown
Michael Brownell
Bill and Kay Burg
Kay M. Doces
Mary Eaglesham
Imogene Gieling
Karen Guzak
Tim and Margo Hill
Anne Hirondelle
Humboldt Arts Council
John C. and Claire Koenig
Greg Kucera and Larry Yocum
James Martin
Sandra Mattice
Philip and Anne McCracken
Daniel Ritter
Claude and Susan Soudah
Margaret Zhu

Literary

2000 Book, *The Gardens of Greece, Known and Unknown*, in manuscript

1998 Book, *The Forgotten Gardens of Byzantium*, in manuscript

1996 Book, *Twisted Tales from a Greek Island*, Athens

1984 English script, "Bordello," Nikos Koundouros, Athens

1974 Catalog, *Karlo Durovic*, Nees Morphes Gallery, Athens

1973 Catalog, *Sam Fischer*, Hydra Gallery, Greece

1972 Editor, *International History Magazine*, Athens

1970 Catalog, *Dikon Eames*, Gallery Ora, Athens

1965 Co-Author, *Voyages*, book and theatre production, Oslo

1961–62 Editor, *Japan Interior Design*, English Edition, Tokyo

Professional

1978–94 Resident in Greece, appearing in Greek, French, British, and American film and television productions in featured roles.

1976–78 Administrator, Merce Cunningham Dance Company, New York.

1969–73 Co-founder, Corfu International Festival with Maestro Thomas Schippers.

1963–69 Founder, Director of Scandinavian Theatre Company, based in Stockholm, Sweden. A professional English language repertory theatre, affiliated with British and American Actor's Equity and the American National Theatre Academy (ANTA). The Company was subsidized by the three Scandinavian Ministries of Education. Artists such as Sir John Gielgud, Dame Peggy Ashcroft, E.G. Marshall, Sala Thompson, Thelma Oliver, and Esther Rolle appeared in the Company's productions.

1962 Assistant to the Argentinian Director, Leopoldo Torres-Nilsson, later given the role opposite Richard Basehart in a film based on the novel by Beatriz Guido and screenplay by Edna O'Brien.

1952 Adult professional debut as a singer.

Languages

English, Norwegian, Swedish, Danish, French, German, Greek

Education

University of Washington, Seattle
University of Oslo, Norway
Pacific Lutheran University, Tacoma

Personal

Born 1930, Tacoma, Washington. Youngest son of Rev. Dr. Trygve Svare (Lutheran pastor, university professor, U.S. diplomat). Resident Europe 1954–1994.

Awards

First Prize for Narration, "Adagio" by Galen Garwood
International Video Festival, Philadelphia, 1998
Honorable Mention: role in "Drifting Cities" Greece-France-Israel Production
International Television Festival, Cannes, 1982
Distinguished Alumnus, Pacific Lutheran University, 1980

Notes

cover Photograph of The Lake, ca. 1982, courtesy Robert Yarber, Morris Graves Foundation Archives, Richard Svare Archives.

cover *inside left:* Photograph (Polaroid) by Robert Yarber, 2000, last photograph of Morris Graves, taken in hothouse at The Lake, collection of Richard Svare, Richard Svare Archives.

cover *inside right:* Portrait of the author, ca. early 1990s, Richard Svare Archives.

frontise Photograph by Dorothy Norman, 1962, at Woodtown Manor: copper glass bottle container, designed by Morris Graves and made in Dublin, Richard Svare Archives, Morris Graves Foundation Archives.

page i Photograph by Mary Randlett, September 1957, at Careläden: interior still life by Morris Graves, courtesy of the University of Washington Libraries Special Collections, Mary Randlett Collection, Richard Svare Archives, Morris Graves Foundation Archives.

page iii Drawing by Morris Graves, ca. 1950, view of living room from fireplace wall at Careläden, pencil on paper, 8.3 x 10.5", Richard Svare Archives.

page v Photograph by Mary Randlett, September 1957, at Careläden: repose and meditation with Randlett's nature portfolio prior to Photo shoot, courtesy University of Washington Libraries Special Collections, Mary Randlett Collection, Richard Svare Archives, Morris Graves Foundation Archives.

page vii Photograph by Mary Randlett, September 1957, at Careläden: still-life arrangement with Michaelmas daisies in portico, courtesy of University of Washington Libraries Special Collections, Mary Randlett Collection, Richard Svare Archives, Morris Graves Foundation Archives.

page viii Drawing by Morris Graves, ca. 1958, Woodtown Manor herb garden, designed for Richard Svare, ink on paper, 10 x 7. 875", Richard Svare Archives.

page ix Photograph by Morris Graves, 1963, at Woodtown Manor: interior drawing room and Hogarth chairs, Richard Svare Archives, Morris Graves Foundation Archives.

Notes on The Rock

Concerning the inventory of historic Photographs of The Rock in the Richard Svare Archive, which Richard initially attributed to 'photographer unknown,' we know today these Photographs were taken by Frank Murphy, who I believe was unknown to Richard Svare, since Richard did not become involved with Morris Graves until long after Frank Murphy, along with Leo Kenney, and others relocated to San Francisco in the late 1940s. Frank Murphy was a master Photographer; he was very prolific and close friends with Leo Kenney, Guy Anderson, Morris Graves, Richard Gilkey, Betty Bowen, and other Contemporaries. Trusted and respected, he took exquisite portraits of these artists and their friends primarily throughout the 40s and 50s, in Seattle and San Francisco. – *Merch Pease*

page 1 *spread:* Photograph by Frank Murphy, ca. 1940, 'Moon over Mt. Baker', Richard Svare Archives.

page 2 Photograph by Frank Murphy, ca. 1940, engraved on the back by Morris Graves as 'Sung Tree', The Rock,

Richard Svare Archive.

Notes on Careläden

Archives, Morris Graves Foundation Archives.

kitchen wing on the right, Richard Svare Archives, Morris Graves Foundation Archives.

page 32 Photograph by Mary Randlett, September 1957, detail of portico pond, natural still life with native plants, courtesy of University of Washington Libraries Special Collections, Mary Randlett Collection, Richard Svare Archives, Morris Graves Foundation Archives.

page 33 Photograph by Mary Randlett, September 1957, noisesome peafowl on daily promenade, in front of oil-painted still life by Morris Graves of elongated table and Chinese urn with flowers on north wall of portico, paneled door to studio on right, courtesy of University of Washington Libraries Special Collections, Mary Randlett Collection, Richard Svare Archives, Morris Graves Foundation Archives.

page 34 Photograph by Mary Randlett, September 1957, view north through dining room, across portico and paneled door entrance to studio in the distance, courtesy of University of Washington Libraries Special Collections, Mary Randlett Collection, Richard Svare Archives, Morris Graves Foundation Archives.

page 35 Photograph by Eliot Elisofon, summer, 1957, Morris Graves in portico with view south into dining room to south wall bay window, silhouette of Richard Svare in the distance. Mexican chairs on wall to the left, Richard Svare Archives, Morris Graves Foundation Archives.

page 36 Photograph by Phyllis D. Massar, ca. 1953, water table at north end of portico pond, courtesy of Richard Svare Archives.

page 37 Photograph by Mary Randlett, September 1957, detail of portico pond, another view, courtesy of University of Washington Libraries Special Collections, Mary Randlett Collection, Richard Svare Archives, Morris Graves Foundation Archives.

page 38 Photograph by Mary Randlett, September 1957, interior studio view, courtesy of University of Washington Libraries Special Collections, Mary Randlett Collection, Richard Svare Archives, Morris Graves Foundation Archives.

page 39 Photograph by Mary Randlett, September 1957, view east from center portico into entrance hall area, right of center floor to ceiling glass panels partially screened with standing sculptural still life of natural materials, by Richard Gilkey, courtesy of University of Washington Libraries Special Collections, Mary Randlett Collection, Richard Svare Archives, Morris Graves Foundation Archives.

page 40 *top:* Photograph by Mary Randlett, September 1957, diagonal view of west wall of dining room with built-in buffet, kitchen entrance, and kitchen bay window, courtesy of University of Washington Libraries Special Collections, Mary Randlett Collection, Richard Svare Archives, Morris Graves Foundation Archives.

page 40 *bottom:* Photograph by Mary Randlett, September 1957, view of south wall and bay window of kitchen across to west wall and kitchen door entrance to woodshed, courtesy of University of Washington Libraries Special Collections, Mary Randlett Collection, Richard Svare Archives, Morris Graves Foundation Archives.

page 41 Photograph by Mary Randlett, September 1957, view of west wall of kitchen across old pine table on which Morris Graves's still life arrangements have been created on top and bottom; above the table is a Morris Graves drawing of two geese, courtesy of University of Washington Libraries Special Collections, Mary Randlett

Collection, Richard Svare Archives, Morris Graves Foundation Archives.

page 42 Photograph by Mary Randlett, September 1957, view east from northeast corner of dining room into skylit hall leading to guest bath and bedroom, courtesy of University of Washington Libraries Special Collections, Mary Randlett Collection, Richard Svare Archives, Morris Graves Foundation Archives.

page 43 Photograph by Mary Randlett, September 1957, view east from southeast corner into guest bedroom, courtesy of University of Washington Libraries Special Collections, Mary Randlett Collection, Richard Svare Archives, Morris Graves Foundation Archives.

page 44 Photograph by Mary Randlett, ca. 1950, Morris Graves, Mark Tobey, and Marian Willard on the occasion of Marian Willard's visit to the Pacific Northwest (Willard was then sole dealer of Tobey and Graves), courtesy of University of Washington Libraries Special Collections, Mary Randlett Collection, Richard Svare Archives, Morris Graves Foundation Archives.

page 45 Photograph by Mary Randlett, ca. 1950, Mark Tobey, on a rare foray into the countryside, an environment he avoided assiduously. He is shelling beans for supper, courtesy of University of Washington Libraries Special Collections, Mary Randlett Collection, Richard Svare Archives, Morris Graves Foundation Archives.

page 46 Photograph by Mary Randlett, August 1949, Morris Graves with his dog, Edith, courtesy of University of Washington Libraries Special Collections, Mary Randlett Collection, Richard Svare Archives, Morris Graves Foundation Archives.

Notes on Woodtown Manor

page 49 Photograph by Richard Svare, 1959, view west of Woodtown Manor House, Richard Svare Archives, Morris Graves Foundation Archives.

page 50 *top:* Photograph by Dorothy Norman, 1962, the Vale of Dublin from Woodtown Manor, Richard Svare Archives, Morris Graves Foundation Archives.

page 50 *bottom:* Photograph by Dorothy Schumacher, 1954, Morris Graves and Richard Svare exploring ruined house, County Cork, Ireland, Richard Svare Archives, Morris Graves Foundation Archives.

page 51 *top:* Photograph by Richard D. Gavin, Dublin, August 1959, scaffolding on front façade, Richard Svare Archives, Morris Graves Foundation Archives.

page 51 *bottom:* Photograph by Richard D. Gavin, Dublin, August 1959, scaffolding on bay window, first and second floor, Richard Svare Archives, Morris Graves Foundation Archives.

page 52 *top:* Drawing by Morris Graves, ca. 1956, early sketch for Woodtown Manor, pencil on paper, 8.187 x 10.437", Richard Svare Archives, Morris Graves Foundation Archives.

page 52 *bottom:* Photograph by Richard Svare, 1958, Morris Graves with restoration crew during construction of Woodtown Manor, Richard Svare Archives, Morris Graves Foundation Archives.

page 64 top: Photograph by Dorothy Norman, 1962, drawing room: painting, right of mantel, by Mischa Dolnikoff, on table, a silk thread sculpture by Thomas Stearns, Richard Svare Archives, Morris Graves Foundation Archives.

page 64 bottom: Photograph by Dorothy Norman, 1962, bay window end of drawing-room with summer placement of furniture, two circular paintngs by Morris Graves, Richard Svare Archives, Morris Graves Foundation Archives.

page 65 Photograph by Richard Svare, 1958–59, Morris Graves at front entrance to Woodtown Manor during early reconstruction, Richard Svare Archives, Morris Graves Foundation Archives.

page 66 Photograph by Richard Svare, 1958–59, early spring, Woodtown Manor House with new windows, roof, and chimneys, Richard Svare Archives, Morris Graves Foundation Archives.

page 67 top: Photograph by Dorothy Norman, 1962, view of kitchen door to terrace, Richard Svare Archives, Morris Graves Foundation Archives.

page 67 bottom: Photograph by Richard Svare, circa 1950s, rare photograph of Morris Graves at work in countryside, Richard Svare Archives, Morris Graves Foundation Archives.

page 68 Photograph by Dorothy Norman, 1962, bow window façade and slate shingled wall, facing north, Richard Svare Archives, Morris Graves Foundation Archives.

page 69 Photograph of Richard Svare and Polly preparing snack, 1958, kitchen terrace, photographer unknown, Richard Svare Archives, Morris Graves Foundation Archives.

page 70 Photograph by Dorothy Norman, 1962, interior still-life arrangement, drawing room table, Richard Svare Archives, Morris Graves Foundation Archives.

page 71 Photograph by Richard Svare, 1958–59, pond during construction, Richard Svare Archives, Morris Graves Foundation Archives.

page 73 Photograph by Dorothy Norman, 1962, interior still life, drawing room, Richard Svare Archives, Morris Graves Foundation Archives.

Notes on The Lake

page 74 spread: Photograph by Ray Kass, ca. 1990s, The Lake, view from Long Room, courtesy Ray Kass.

page 76 Photograph, ca. 1990s, lake shore on a misty day, courtesy Robert Yarber, Richard Svare Archives, Morris Graves Foundation Archives.

page 77 Photograph by Ray Kass, 1980, The Lake, main house and studio, courtesy Ray Kass.

page 78 Photograph by Ray Kass, ca. 1980–81, outer garden, courtesy Ray Kass.

page 79 top: Photograph by Ray Kass, ca. 1980–81, view toward inner and outer garden area, off kitchen, courtesy Ray Kass.

page 79 bottom: Photograph, circa 1980s, Morris Graves, Robert Yarber, photographer unknown, courtesy Morris Graves Foundation Archives.

Notes on Poems

"Once More, The Round," copyright © 1962 by Beatrice Roethke, Administratrix of the Estate of Theodore Roethke, from COLLECTED POEMS OF THEODORE ROETHKE by Theodore Roethke. Used by permission of Doubleday, a division of Random House, Inc.

"Bird of Flight," by Galen Garwood, from *Adagio* copyright © *1995*
"Red Raft On Yellow River," by Galen Garwood, from *Adagio* copyright © *1995*
(In 1995, Richard Svare agreed to do the narration for *Adagio,* a multi-media work I had completed and which premiered at University of Washington's Meany Hall. When I first read the manuscript for *Morris Graves: His Houses, His Gardens*, I was happily surprised and honored that he chose to include these two poems, especially because "Bird of Flight" had been written for Morris Graves. – G.G.)

Book Editors

William O'Daly is a longtime literary editor and a technical editor, a poet, translator, and prose writer. His published works include eight books in translation of the poetry of Chilean Nobel laureate Pablo Neruda and a chapbook of poems. A finalist for the 2006 Quill Award in Poetry, he is a National Endowment for the Arts Fellow. With co-author Han-ping Chin, he recently completed a historical novel, *This Earthly Life*, selected as a Finalist in Narrative magazine's 2009 Fall Story Contest. O'Daly is co-founder of Copper Canyon Press, and has received national and regional honors for literary editing and instructional design.

Deborah Mangold is a writer and an oral history researcher/archivist. She lives in Seattle, Washington.